Remembering
Corpus Christi

Cecilia Gutierrez Venable

TURNER
PUBLISHING COMPANY

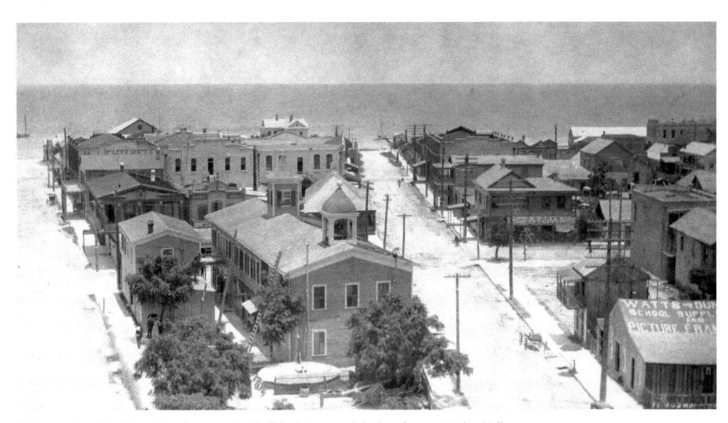

This view from North Broadway Street on the bluff, looking toward the bay, features Market Hall. This building served as a place for vendors. Graduation exercises, parties, and other recreational activities were held on its second floor. The narrow building on the left was used as City Hall. Across the street is the Watts and Dunne school supplies shop.

Remembering
Corpus Christi

Turner Publishing Company
www.turnerpublishing.com

Remembering Corpus Christi

Library of Congress Control Number: 2010926201

ISBN: 978-1-59652-675-4

Printed in the United States of America

ISBN 978-1-68336-823-6 (pbk.)

CONTENTS

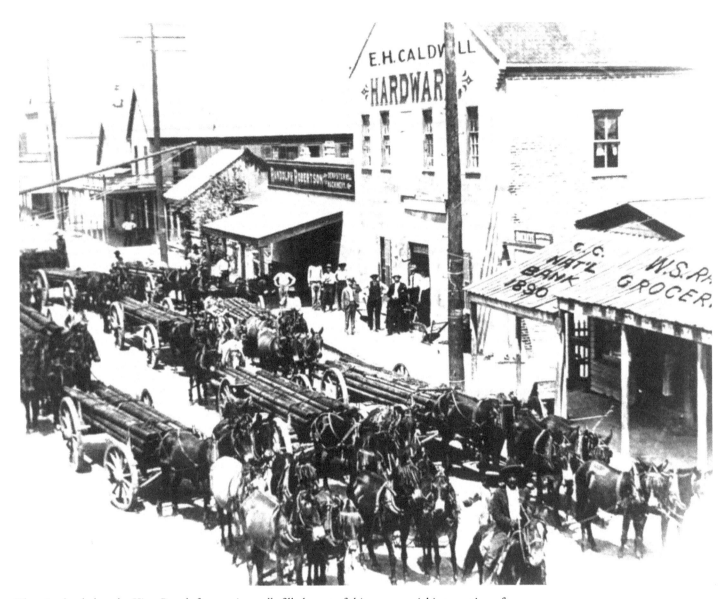

The pipe hauled to the King Ranch for artesian wells filled most of this commercial intersection of Chaparral and Peoples streets on this 1890s day. Several businesses are also pictured, including the W. S. Rankin Grocery Store; C. C. National Bank; E. H. Caldwell's Hardware Store; Randolph Robertson's Well Machinery shop; Western Union office; and a two-story building which held a store at the street level and a hall for dancing or skating on the second floor.

ACKNOWLEDGMENTS

This book resulted from the cooperation and aid from many institutions and individuals. The vision, dedication, and hard work the Corpus Christi Public Libraries has invested in its collection made possible a large majority of the photographs for this publication. The library director, Herb Canales, and Laura Garcia, Gerlinda Riojas, and Norma Gonzalez, were invaluable resources. Thanks also to Rebecca Jones for her work on the photographs.

Texas A&M University-Corpus Christi Special Collections and Archives donated several images for this publication, and a special thanks to Grace Charles, who was indispensable in finding images. The input of Dr. Thomas Kreneck, Jan Weaver, and Mike Rowell was much appreciated.

The Library of Congress also provided images from its extensive holdings.

The expertise of local historians Bill and Marjorie Walraven, Anita Eisenhower, and Murphy Givens was also important in the completion of this work.

Finally, I would like to thank Audrey Flores for her dedication in putting this book together. Her hard work and perseverance were greatly appreciated. The patience and understanding of my husband, James C. (Jake) Venable, and daughter, Breanna Venable, were immeasurable.

PREFACE

Little more than a century old, Corpus Christi is a relatively young city. However, the land it rests on is thousands of years old. Ice age sea level changes, as well as sedimentation and deposition from rivers, helped the land and bay emerge to form an ideal area for a port town. One of the first to explore the Gulf Coast was the Karankawa Indians. Nomadic, they followed game and harvested mollusks, fish, and berries in the area. Several European expeditions landed on the shores as early as the late sixteenth century but established few permanent settlements. It would take the foresight of an ambitious entrepreneur to plant the seed for the city's development.

Henry L. Kinney arrived near Corpus Christi in 1839, fleeing scandalous affairs and failed business dealings. This charismatic fortune hunter sought to profit from outfitting troops and found the area to be conducive to such efforts. Always a profiteer, Kinney tended to favor whoever provided the best deal. When Zachary Taylor's troops camped in the area in 1845, many people passed through town, but few stayed. In order to attract settlers, Kinney held one of the first state fairs, but this scheme also failed to attract new residents. By 1854, Corpus Christi nevertheless had schools, churches, a strong organization for women, and fraternal lodges. When yellow fever struck later that year, many citizens perished, but Kinney remained optimistic about the city's future and continued to advertise the area's attributes to the northern states and European countries. After the Civil War broke out, Kinney fled to Mexico in search of another pot of gold . There his fortunes were ended by two bullets when he pursued a rendezvous with a woman already spoken for. He died that night in 1862.

The Civil War disrupted the area. In 1863, Union forces blockaded the bay and pummeled the city with shot and shell on several occasions. At the end of the war, the town experienced a surge in population, attracted to town by the prospering cattle and sheep business. These goods could be processed and shipped to other parts of the

country. When the railroad arrived around 1875, shipping, industry, and numerous businesses flocked to Corpus Christi, along with several boosters—in particular, Elihu H. Ropes. He wanted to deepen the port, and he marketed the area as the "Chicago of the Southwest," but his dreams fell through with the Panic of 1893. Ropes died during a trip to solicit northern investors.

Despite Ropes' failure, the city attracted additional railroads, which promoted the area in hopes of increasing the number of people needing their rails. As more tourists and new residents came, additional hotels, houses, and businesses sprang up to accommodate the growing city. Many of these new structures and entities would be destroyed in 1919 by one of the most devastating hurricanes ever to hit the area. Hundreds of people died in the disaster, and many of the buildings were washed away. The city would not recover from this economic loss for at least seven years.

The Corpus Christi port, which opened on the seventh anniversary of the hurricane—September 14, 1926— spurred growth dramatically and transformed the town into a modern city. Less than ten years after the opening of the port, the population doubled, new office buildings dotted the city's landscape, and larger hotels opened for business. By the 1930s, the oil industry had become an important part of the economy and cushioned the devastating effects of the Great Depression. The city's population again doubled and continued on an upward trend with the arrival of the Naval Air Station in 1941. After World War II, the oil and gas industry boosted the economy with further development of refineries. The port also increased its capabilities, handling various exports including cotton, grains, petroleum products, crude petroleum, and natural gas. Tourism remained a boon for the area and brought in many businesses.

This book captures the city's development through a collection of photographs depicting the history of the area, its people, and important events. With the exception of touching up imperfections that have accrued with the passage of time and cropping where necessary, no changes have been made to the images. The focus and clarity of many images are limited to the technology and the ability of the photographer at the time they were recorded. Many hundreds of photographs were sifted in order to assemble this collection and many hours of research were expended in an attempt to achieve a well-balanced view of the city's life. Where gaps in the record exist, images were scarce or missing altogether. The reader is encouraged to enjoy this look at Corpus Christi through the lens of the past, with the goal of helping to think about and plan for the city's future.

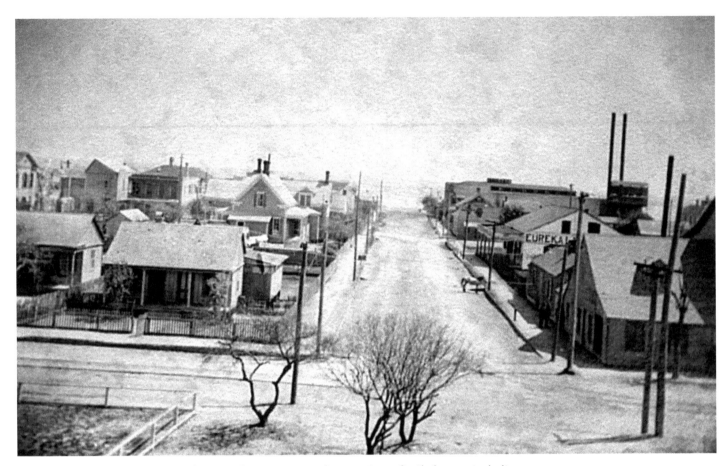

This 1880s early waterfront view of Laguna Street captures a few prominent family homes, including the Meuly and Robertson homes. Randolph Robertson operated a well machinery shop near Chaparral and Peoples streets. Herman Meuly operated a newsdealer, bookseller, and stationer business. Several businesses can also be seen, including the ice and power industry plant with its tall smokestacks.

Seaport Town Through the Gilded Age

(1870s–1889)

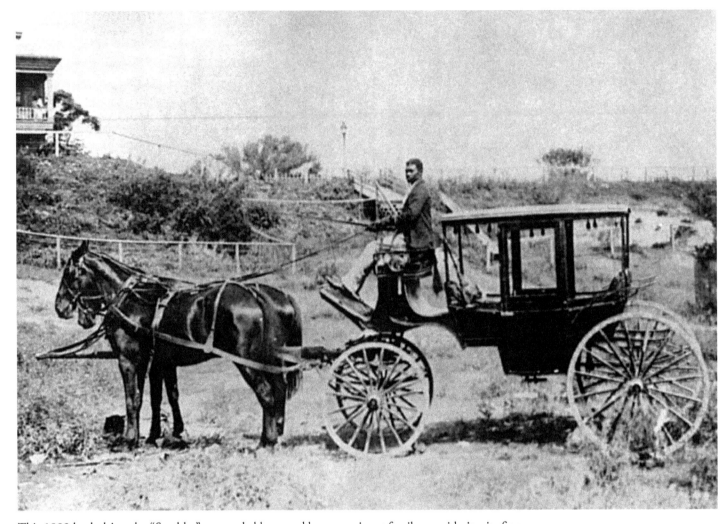

This 1882 hack driven by "Scudder" was probably owned by a prominent family, considering its fine horse and carriage. Hacks were also used by the city for various services. James M. Hunter, who owned a livery and stable on Water Street near Lawrence, also owned a hack, which the city used occasionally to haul prisoners to the jail for a fee of $3.

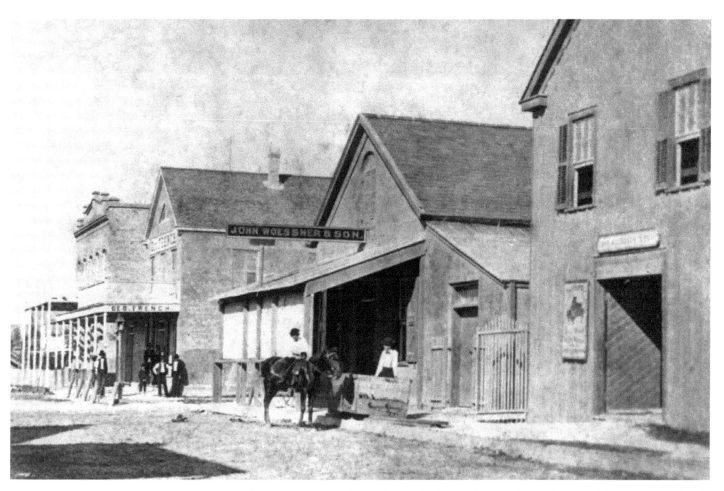

This view of Chaparral Street highlights John Woessner & Son. Next to it is the George French merchandise store, which opened in the late 1860s. French was also an active member of the city. He held positions of county treasurer, alderman, and fireman.

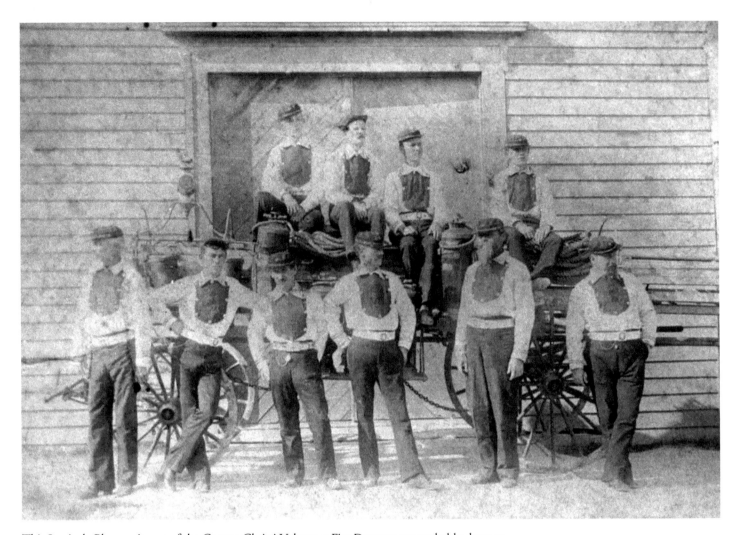

This Louis de Planque image of the Corpus Christi Volunteer Fire Department probably dates to the late 1870s. William Rogers organized the Pioneer Fire Company No. 1 in 1871 with ten men who purchased their own uniforms. Early members included Felix Noessel, foreman; Peter Benson, assistant foreman; L. D. Brewster, second assistant; and Ed Buckley, treasurer. This group also determined what the fire department needed and solicited funds for equipment.

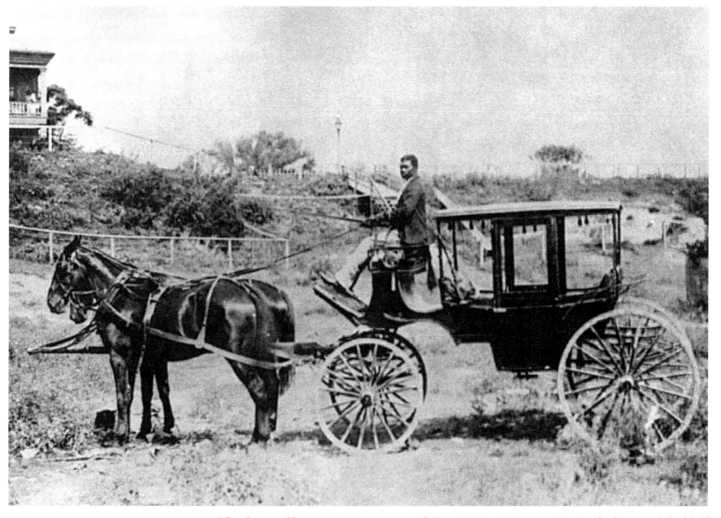

The Corpus Christi Fire Department and Security Hose Company No. 3, which covered the bluff area, stands in front of Market Hall for the start of a parade. Firemen used the second floor of Market Hall for recreation, and a fire bell dedicated on May 6, 1873, hung in the tower. The bell summoned firemen when there was a fire and also alerted citizens to the time of day, called children to school, and announced social events.

The United States Weather Bureau sits atop the George French building on the corner of Star and Chaparral streets. The weather bureau occupied two rooms on the second floor of this building. The station was forced to find another location because their original building in Indianola was destroyed by a hurricane. This station opened on February 1, 1887, and remained at this location until July 9, 1901.

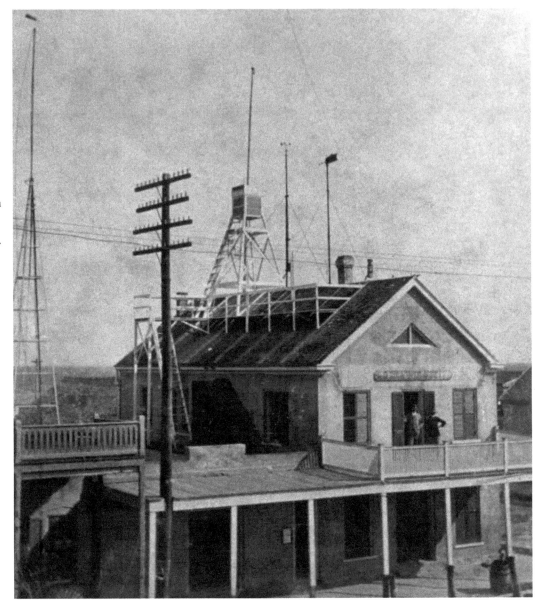

Progressive Era

(1890–1925)

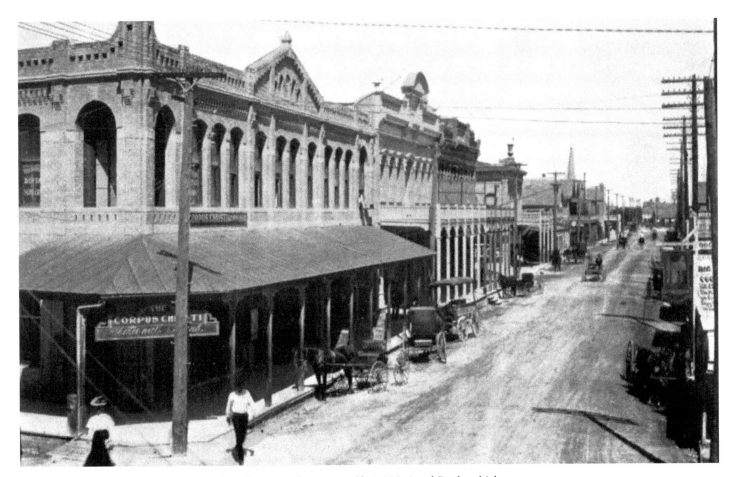

This early view of Chaparral Street at Schatzel features the Corpus Christi National Bank, which moved to this location in 1891 and operated there for 69 years. Next door is the Corpus Christi Book and Stationery Company. Across the street is the Joe Mireur Shop "Outfitter to the Horse." This store sold and repaired leather goods. The city purchased various items from this store, including bridles, rope, and cremoline.

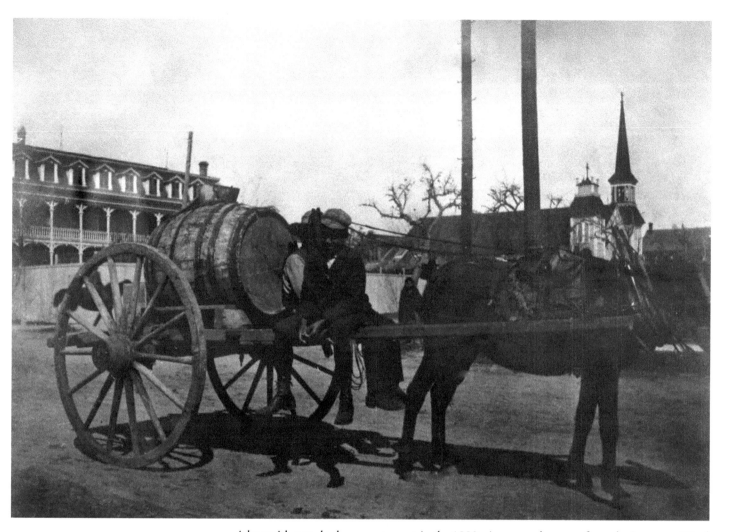

A boy with a mule-drawn water cart in the 1890s sits across the street from the Incarnate Word Academy. Hauling water in times of drought was the job of men called "*barrileros*," and it was quite a chore, especially in outlying areas of the city. The city's new water system provided assurance of fresh water from the Nueces River and relieved citizens of total dependence on cisterns for their water supply.

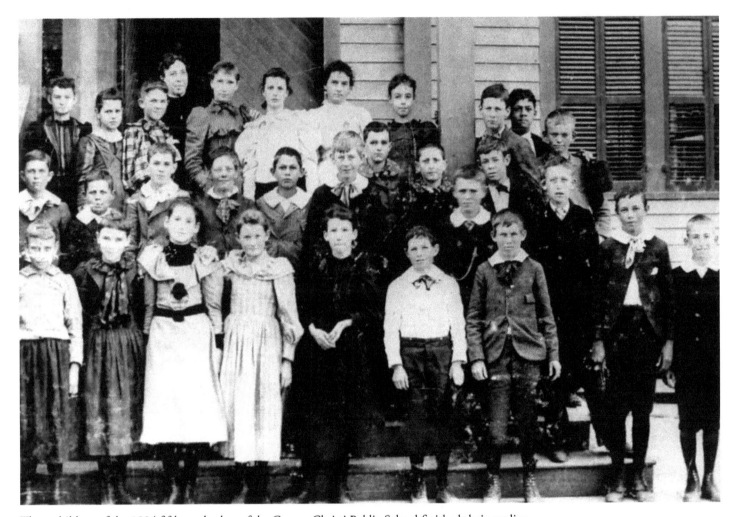

These children of the 1894 fifth-grade class of the Corpus Christi Public School finished their studies; the next year's students weren't so fortunate. The city spent a great deal of capital on the water supply system, then faced reduced revenue due to the 1893 panic. School funding dropped. Consequently, in 1895, school trustees required payment of a dollar a month for intermediate grades and three dollars for high school, for those who wished to continue their education.

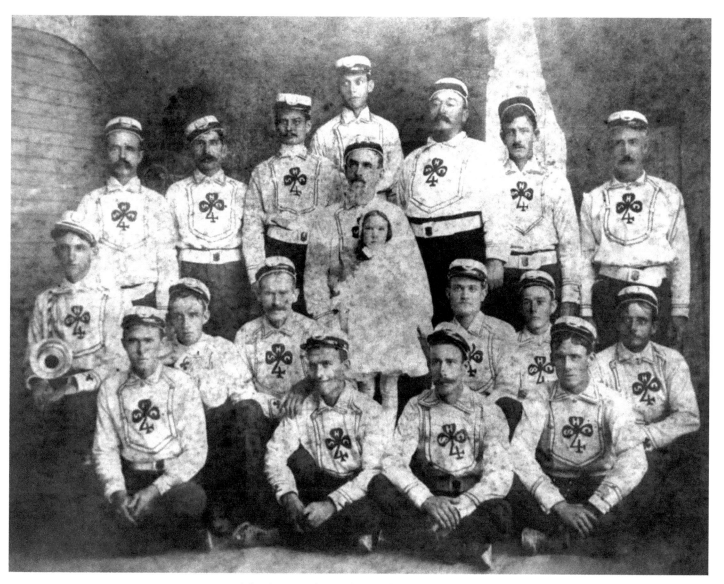

The Corpus Christi Shamrock Hose Company No. 4, shown here around 1900, patrolled the northeastern part of the city. In the first row, from left, are Joe Mireur, Joe Davidson, Tom Poulson, Charles Lege, and John Gollihar. On the second row are John Davidson, Peyton Smythe, Jim Falvilla, Lucien Young, Willie Young, Clem Vetters, Farrell Benson, Charlie Wilkerson, Tompkins (first name unknown), Max Luther, Bill Gollihar, Wison Rankin, and Joe Dunn. The little girl is Annie Rankin.

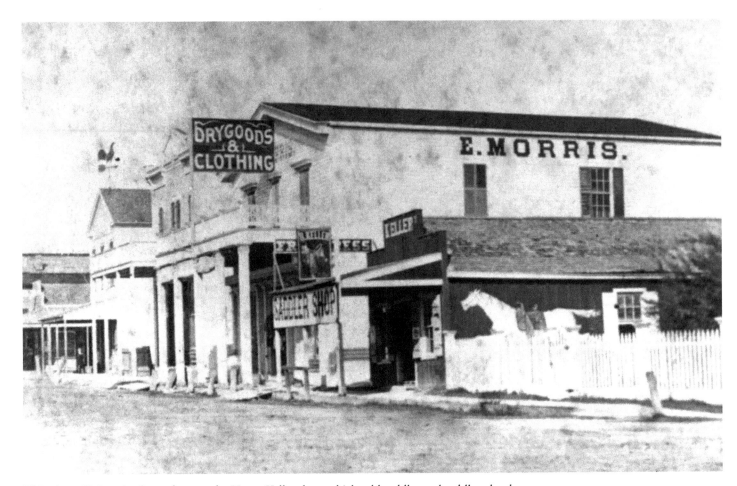

This view of Mesquite Street features the Henry Keller shop, which sold saddles and saddlery hardware as well as buggies, carriages, and ambulances. This shop was sold to Joe Mireur in 1903. Next to the saddlery is E. Morris' dry goods and clothing store, followed by Norwick Gussett's and El Barego, which bought and sold wool and hides. El Barego also served as a meeting place for vaqueros and traders.

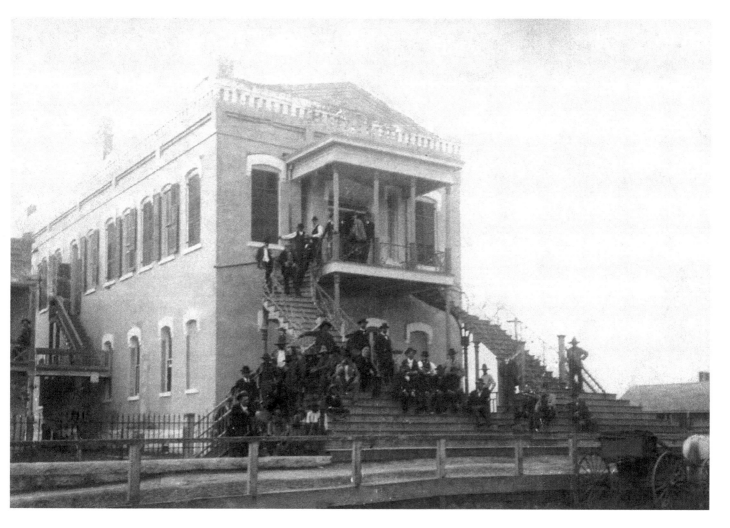

Law enforcement personnel gather on the Hollub Courthouse steps. This 1875 facility designed by Rudolph Hollub replaced the old Nueces County Courthouse (building on left) at Mesquite and Belden streets. The old building was designed by Felix A. Blucher, a surveyor and architect, in 1853. Both buildings were connected by a stairway and deck, and both structures were later replaced by the construction of the 1914 courthouse.

Jailers and residents pose in front of the Nueces County Jail, which stood near the Nueces County Courthouse on the 1100 block of Mesquite Street. While the building had fine architecture, it appeared quite bleak because of the desperate prisoners who often peered out its windows, as shown in this picture.

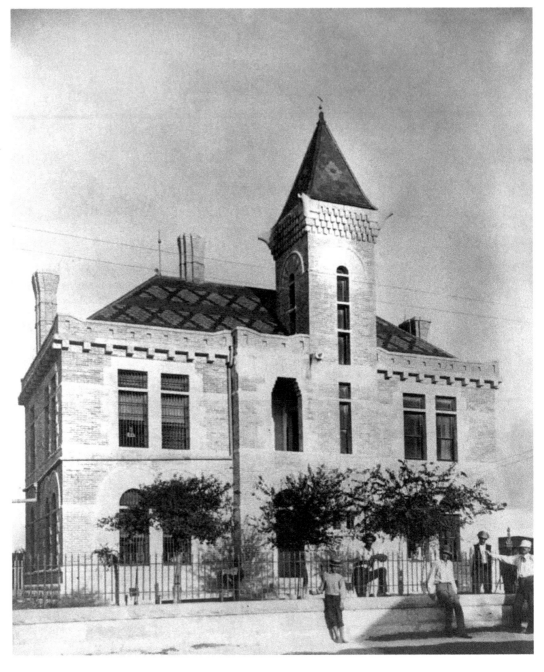

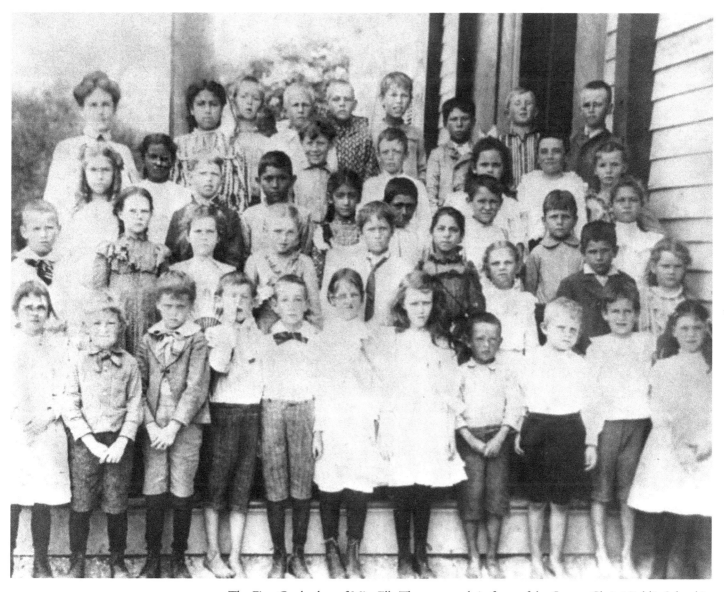

The First Grade class of Miss Ella Thomas stands in front of the Corpus Christi Public School in 1901. Thomas' salary this year was $50 per month. The Corpus Christi Public School system had 532 students and 16 teachers that year.

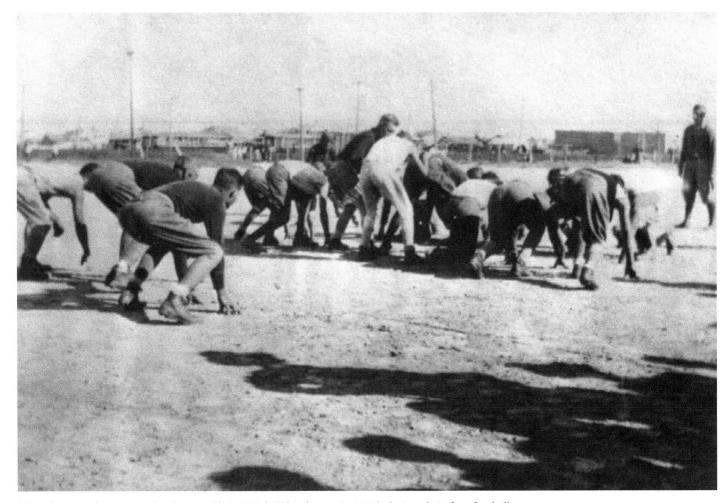

This photograph captures the Corpus Christi High School team in 1904 playing their first football game.

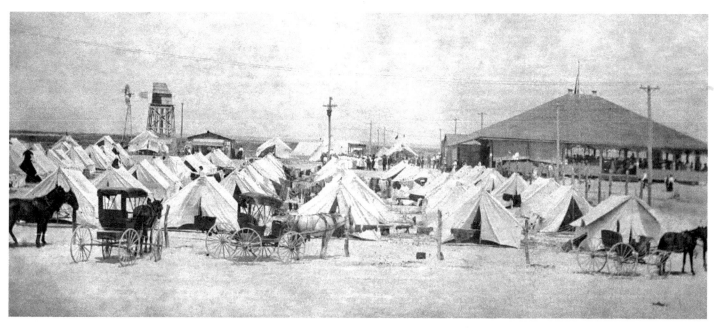

This panoramic view of North Beach, where the Methodist Church held summer camp meetings, illustrates the temporary tent cities that drew crowds. With the building of Epworth the number of tents diminished; however, these camps could still be found near the inn for those who still wished to stay on the beach, or at peak season, for those who could not find rooms at the hotel.

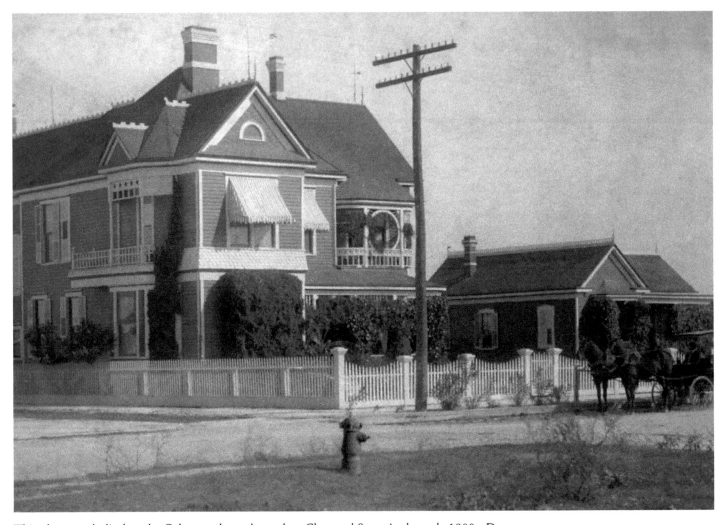

This photograph displays the Culpepper home located on Chaparral Street in the early 1900s. Doctor Arthur Spohn used this home as his first hospital. The horse and carriage may be waiting to take the doctor on a house call.

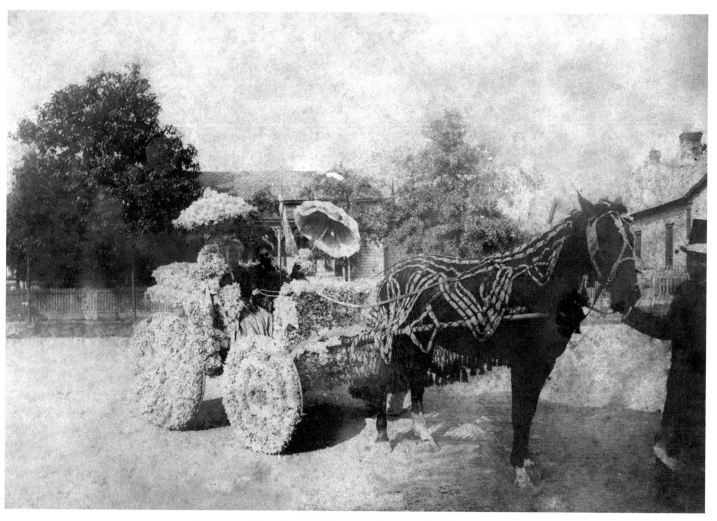

A groom holds a decorated horse and carriage for these two women. The wagon is probably headed for a parade.

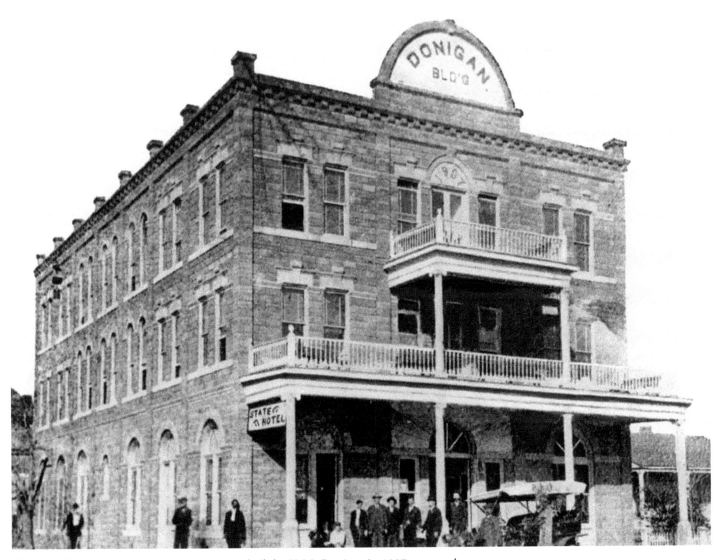

The State Hotel located on Star and Mesquite, built by V. M. Donigan in 1907, attracted many visitors to the city. This hotel also housed the Corpus Christi Public Library after the 1919 hurricane destroyed many of the books at its old location in the Hatch and Robertson building. The hotel closed in 1960, and by 1964, the city sought to tear it down.

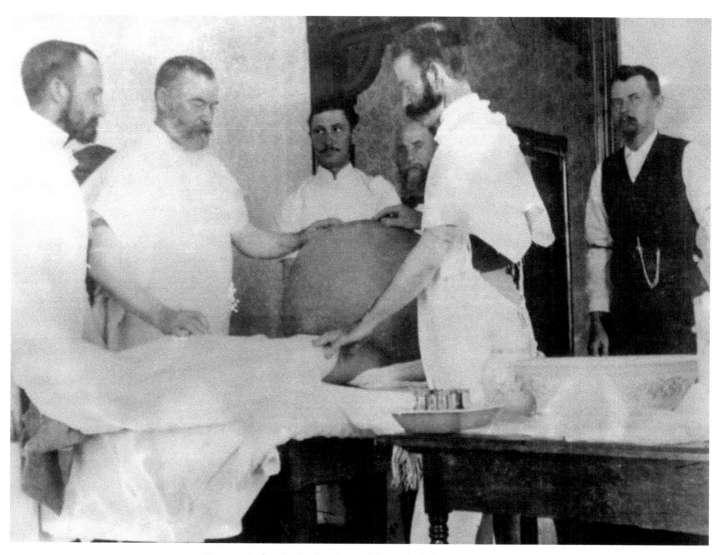

Doctor Arthur E. Spohn (second from the left), along with his assistants, are surveying a patient who has some sort of tumor. Doctor Spohn arrived in Texas in 1868 and later married Sarah Kenedy. He practiced medicine in Corpus Christi until his death in 1913. He was the first president of the Nueces County Medical Association and opened the Spohn Sanitarium on North Beach in 1900.

This is the first official Convent of the Incarnate Word, built in 1886 under Claude Jaillet. The sisters of the Incarnate Word arrived in Corpus Christi in 1871. They took up residence at the home of Father St. Jean, where they opened a small school. The sisters taught German, French, Spanish, Painting, Drawing, and Sewing. This facility was later built to accommodate the growing number of students.

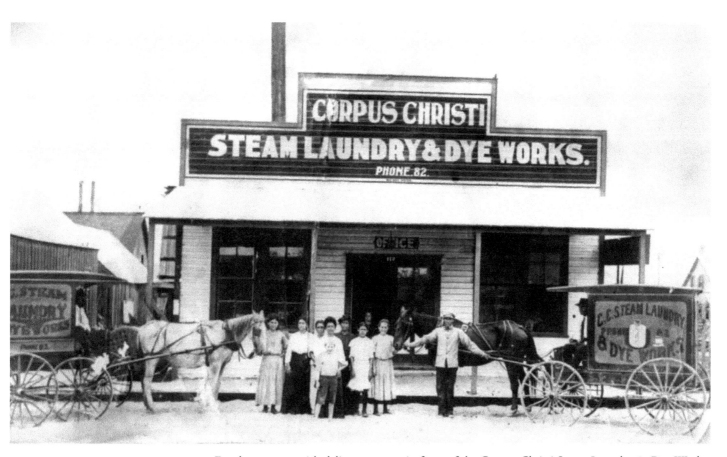

Employees pose with delivery wagons in front of the Corpus Christi Steam Laundry & Dye Works, located at 112 Mesquite in 1907. The owner, John C. Selvidge, opened this business prior to 1904. By 1915, Mrs. A. B. Selvidge became the owner.

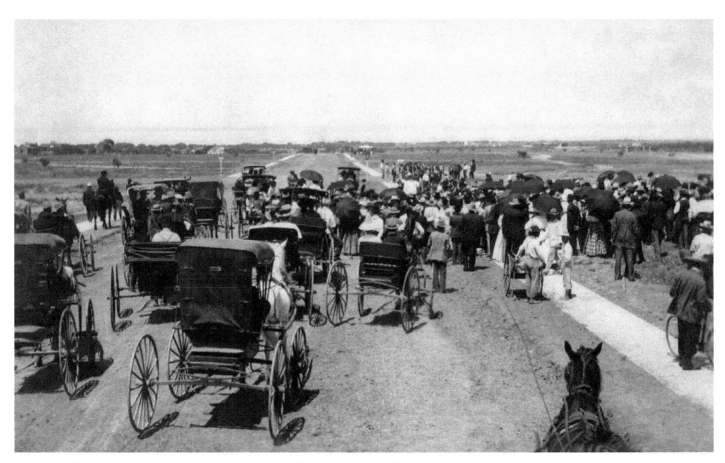

A crowd gathers to view the groundbreaking of a new addition to the west of the city, located on Leopard Street. A lot was to be given out to some lucky resident, which encouraged many to attend.

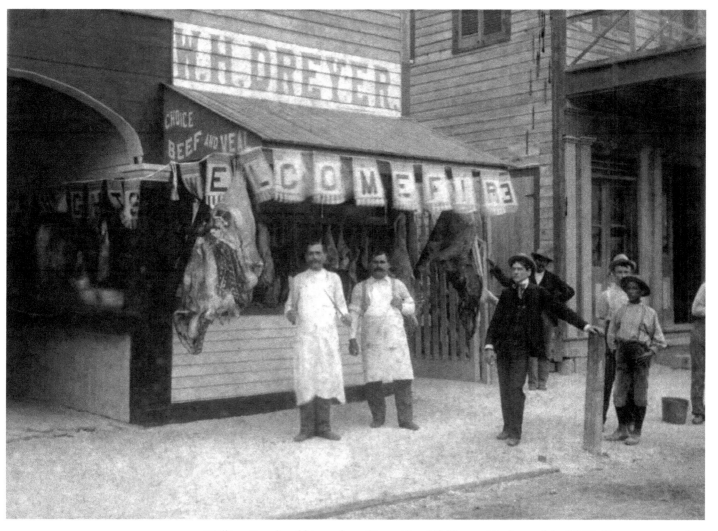

William Petzel and his nephew, Henry Petzel (left), stand in front of the W. H. Dreyer meat market. Mr. Dreyer boasted he was "the leading butcher and meat man in Corpus Christi." This establishment occupied stalls one and three on the north side of city market, located on Peoples, Schatzel, and Mesquite streets. The building is decorated to welcome firemen for the Firemen's Ball, held upstairs in the ballroom.

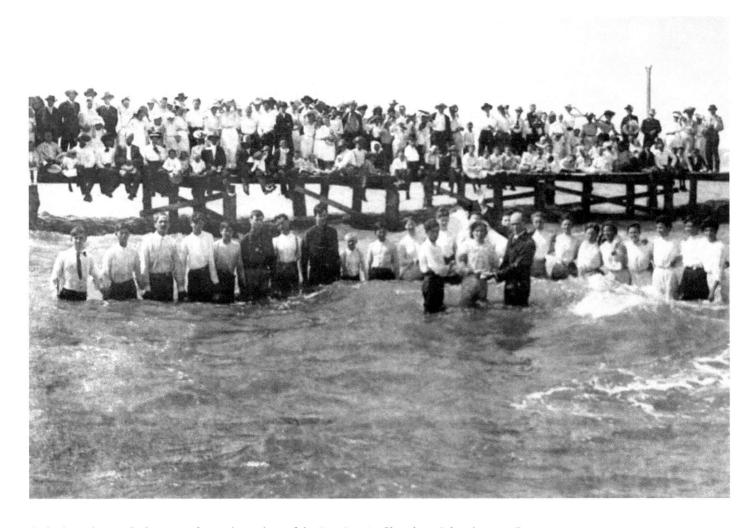

Onlookers observe the baptism of several members of the First Baptist Church on July 14, 1907. D. B. South was pastor of the church at this time. Central Wharf, which provided seating for observers in this photograph, washed away during the 1919 storm.

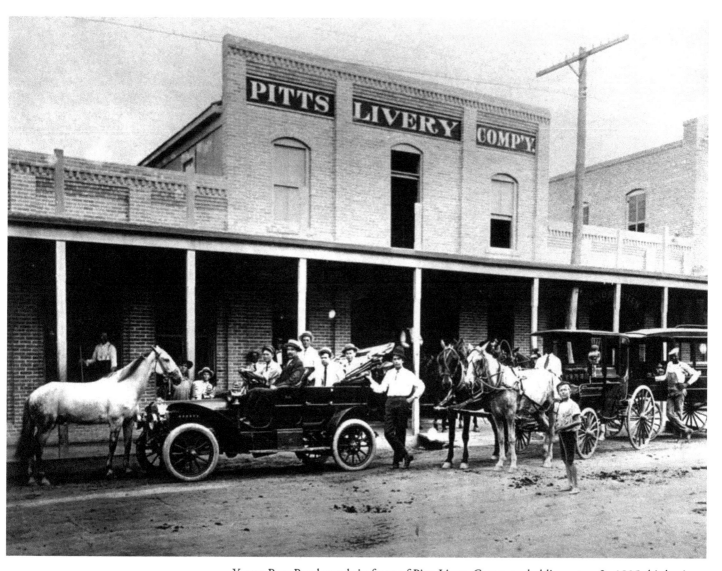

Young Burt Boyd stands in front of Pitts Livery Company, holding a top. In 1905 this business operated as Pitts, Simmons, & Brown Livery and Stable, but by 1908 became Pitts and Baker Livery and Boarding Stable at 310 Mesquite. It provided various services including caring for horses, funeral transportation, and automobile transportation. By 1905, it changed to Fivel and Pitts Garage and Repair Shop, which repaired and sold automobiles. Wearing a black hat and standing behind the white horse at left is Frank Albin Robert Miller. Born in 1889, Miller would die just short of his 99th birthday, witnessing nearly a century of Texas history.

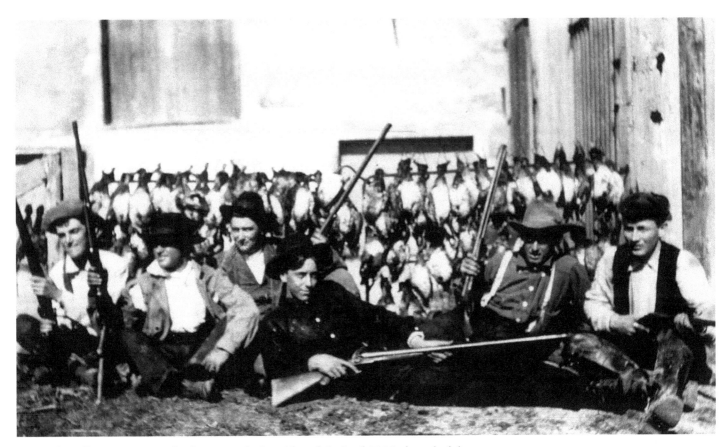

After a day of hunting just south of town on the Poenish tank in April 1905, these duck hunters hauled their catch to the back of E. H. Caldwells Hardware Store and posed for this picture. The hunters (left to right) are Frederic Louis Magnenat, Robert Hall, Lawrence Grimage, John Biggio, Sam Anderson, and Joe Downey.

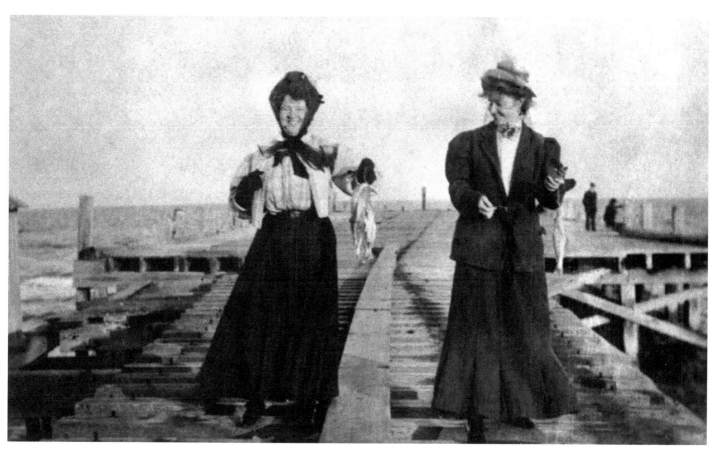

These two women stroll down Central Wharf on March 3, 1908, carrying their catch for the day. Central Wharf, located between Williams and Laguna streets, had many functions. It was used to load cattle and other cargo onto ships, provided good access for fishermen, and by 1903, had a bathhouse that supplied fresh water for showers.

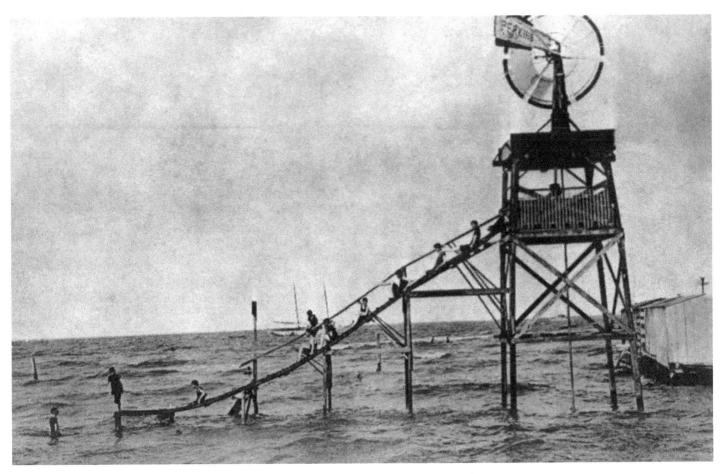

This slide, "Old Nat," near Twigg Street and the Natorium Bathhouse, supplied ample fun for residents as well as visitors. The windmill drew water from the bay and poured it down the slide to add momentum and speed for these enthusiasts.

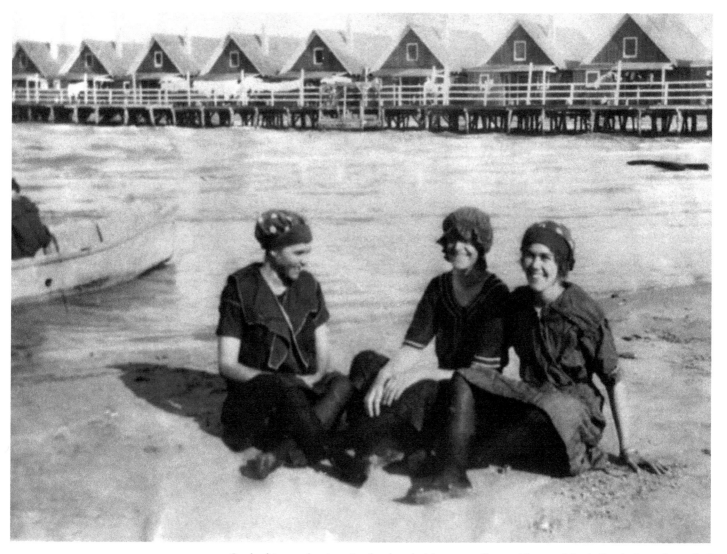

Sunbathing and swimming has lured visitors as well as residents to North Beach since the end of the nineteenth century. These young women sharing the joys of their youth in their stylish 1909 beachwear are a sample of the tourists who congregated in this area. In the background are the wood-framed tourist cabins of Ring Villa, built by F. E. Ring. They did not survive the 1919 hurricane.

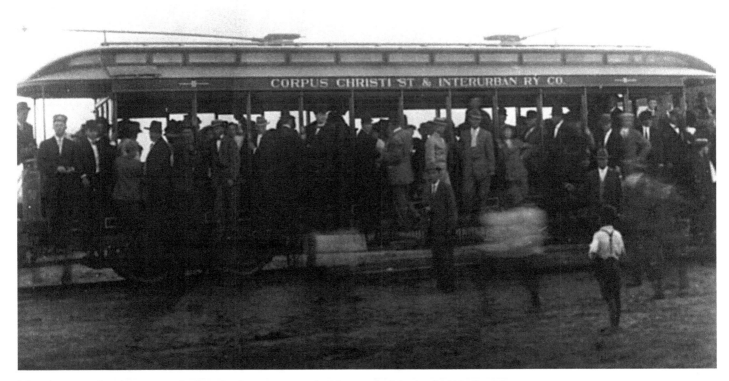

This electric trolley drew a crowd when the first car approached its stop in March of 1910. Daniel Hewitt, proprietor, ran a loop through the city to North Beach. At a nickel a ride, passengers traveled around town at a speed of 10 to 15 miles an hour. In 1911, the company experienced financial difficulties and was sold to the Heinley Brothers of Denver, which operated as the Corpus Christi Street and Interurban Railway Company.

This majestic North Beach structure, called Corpus Beach Hotel or the Breakers Hotel, catered to Corpus Christi's increasing number of tourists in 1912. During World War I it was transformed to become the U.S. Public Health convalescence hospital. A year after war's end, the 1919 hurricane slammed into the building, severely damaging it. After years of neglect, the hotel was restored, only to be destroyed by Hurricane Celia in 1970.

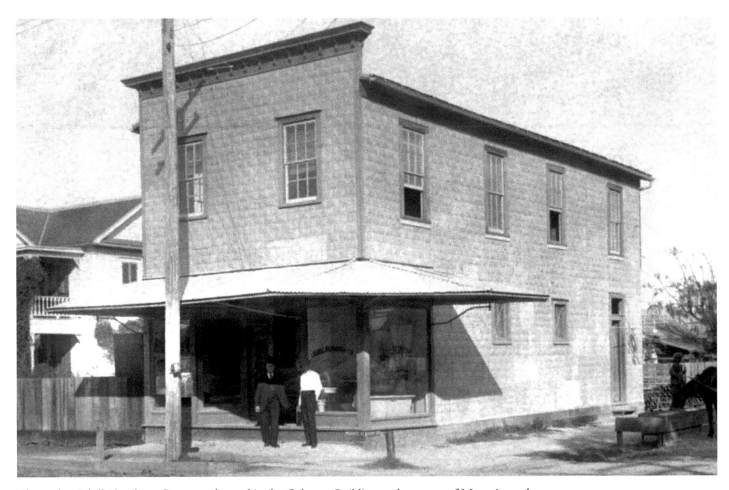

This is the Cahill Plumbing Company, located in the Coleman Building at the corner of Mesquite and Starr streets. During the second decade of the twentieth century, when this picture was taken, Corpus Christi only had three plumbing businesses listed in the city directory.

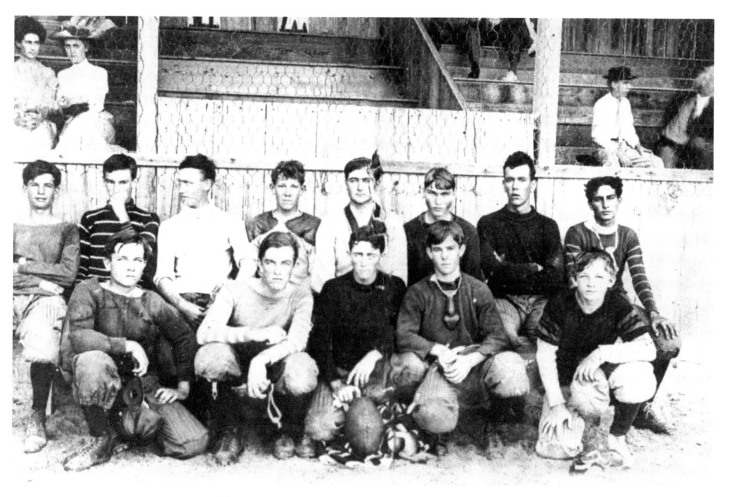

The 1910 Corpus Christi High School football team poses in front of the bleachers on the football field.

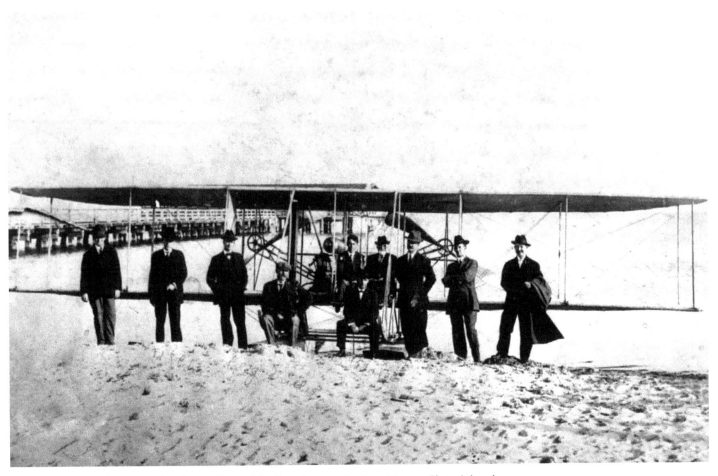

In 1912, a group of men stand in front of one of the first planes to land on Corpus Christi's beach. The Pavillion Hotel Pier, in the background to the left, extended from Taylor Street.

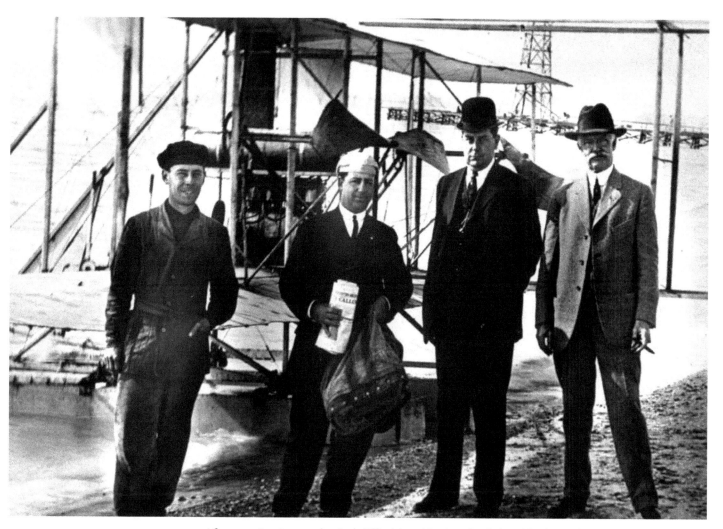

After experiencing mechanical difficulties, this plane landed on North Beach in 1913. The men from left to right are Charles de Remer, W. G. Blake, E. G. Crabbe, and Eli Merriman. Remer, the pilot, was attempting to deliver mail to Port Aransas, but since he could not make the trip, it was sent by boat.

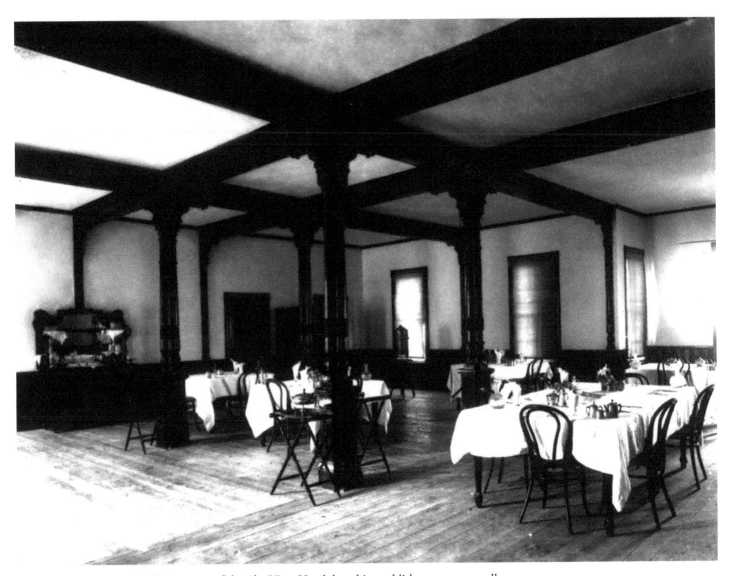

Tables await guests in the dining room of the Alta Vista Hotel, but this establishment never really opened. Elihu Harrison Ropes began construction, and in 1891 the unfinished hotel hosted a ball, but the 1893 panic eliminated funds for its completion. New owner J. J. Copley purchased the building in 1905 and furnished the hotel, but abandoned the building in 1912. In 1927, fire destroyed the structure.

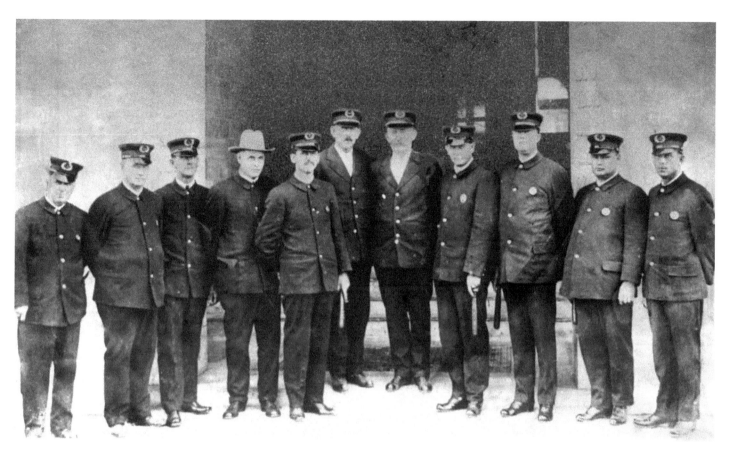

This photo features members of the city's 1914 police department. From left to right are Pat Feely, Ike Johnson, Willie Petzel, Ed Nycum, Lee Petzel, Chief Claude Fowler, John White, Doc Scogin, J. W. Priestly, O. B. Prather, and Glen McCauly.

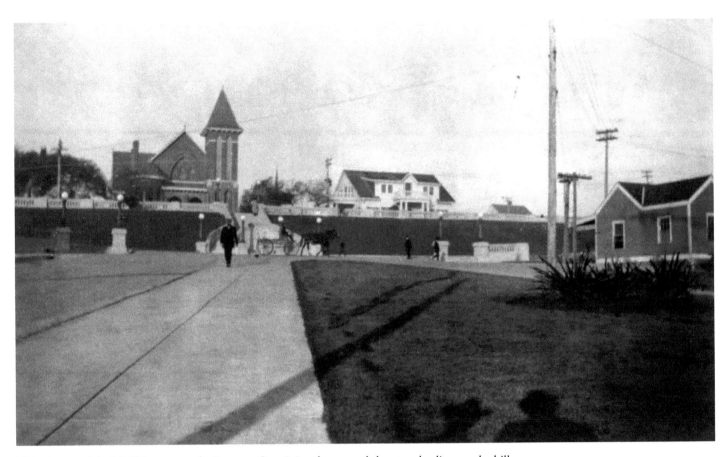

This picture of the bluff focuses on the Pompeo Coppini sculpture and the steps leading up the hill toward the Presbyterian Church, around 1914. This art sculpture features a woman in the center, which represents Corpus Christi, receiving blessings from Mother Earth and Father Neptune. The Presbyterian Church behind the sculpture was completed in 1901 and provided services until 1929, when the building was sold.

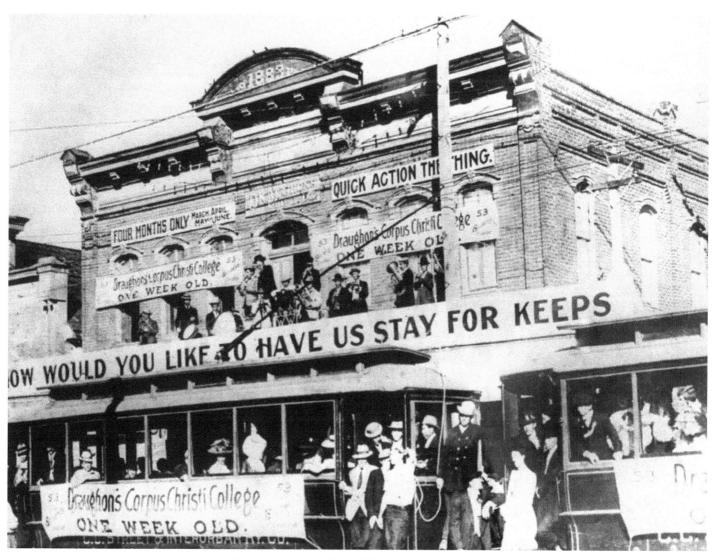

The Draughons College of Corpus Christi was part of a chain of business colleges that sprouted throughout the United States because of the efforts of Professor John F. Draughon. He began these institutions in 1879 and in Corpus Christi advertised the teaching of Spelling, Machine Bookkeeping, Comptometer, Cotton Spanish Business Administration, Salesmanship, Higher Accounting, Business English, Shorthand, Typewriting, Bookkeeping, Accounting, Correspondence, Filing, Penmanship, Business Arithmetic, and Commercial Law.

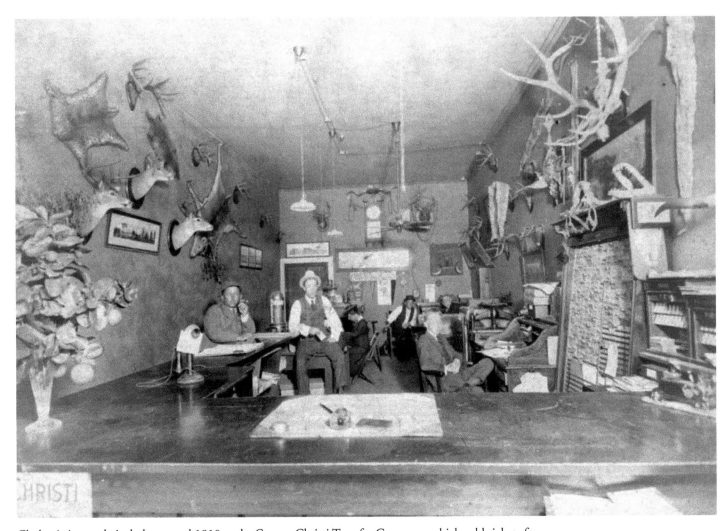

Clerks sitting at their desks around 1910 at the Corpus Christi Transfer Company, which sold tickets for the San Antonio & Aransas Pass Railroad Company (S.A.A.P.), located at 614 Chaparral Street. This line would merge and change its name, and finally link this area with the Louisville & Nashville line.

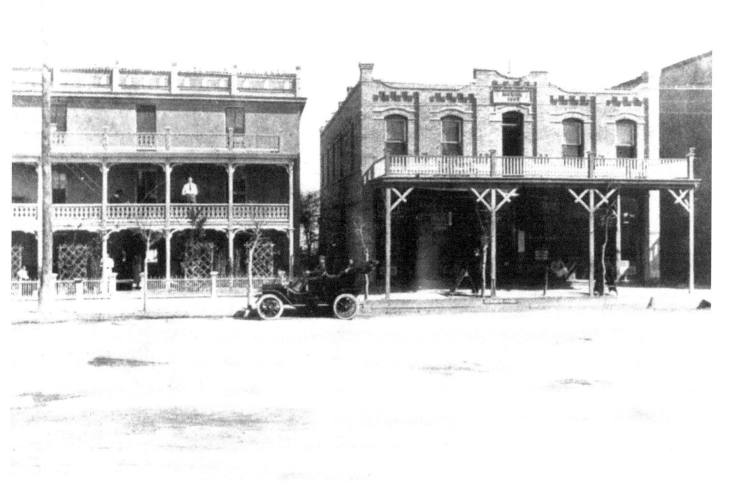

The Horne Apartments in the early 1900s were located at 716 Chaparral. A resident peers into the street, while a woman sits on the balcony reading. Mrs. Helen R. Horne operated the apartments in 1899. Forty-seven years later, in 1946, she decided to close, because at age 75 she wanted to retire.

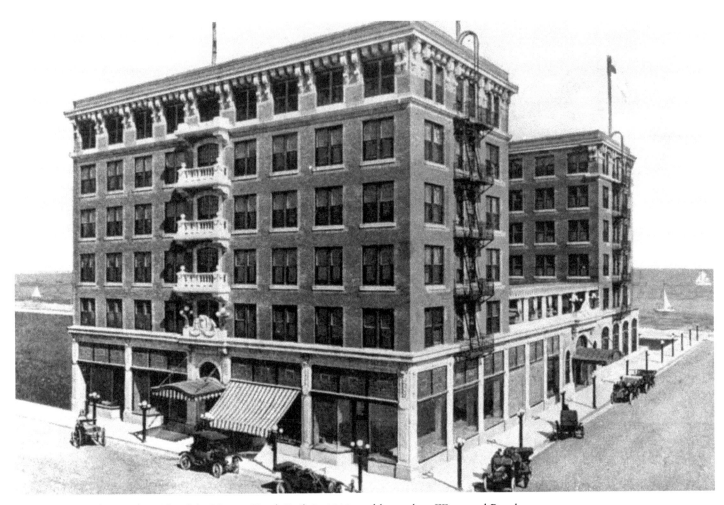

Automobiles park on either side of the Nueces Hotel. Built in 1913, and located on Water and Peoples streets, the building had a wonderful bay view. Tourists and residents alike flocked to this elegant hotel, and many business meetings were conducted in its dining room and on its sun porch. The building received damage from Hurricane Celia in 1970 and was torn down the following year.

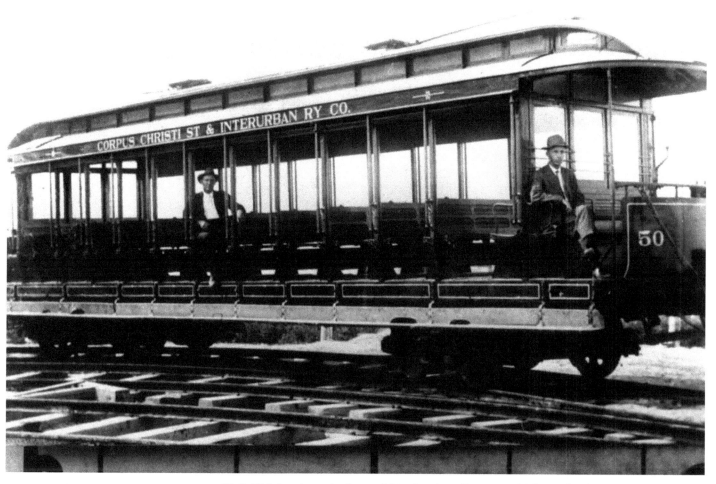

U. S. Heinley sits at the front of this electric trolley in 1914. This trolley belonged to the Corpus Christi Street and Interurban Railway Company, which the Heinley Brothers bought in 1911 from Daniel Hewitt. This enterprise eventually expanded city routes and added three new cars to their fleet. The 1919 hurricane destroyed most of the track, which was later repaired and operated by the company until 1931.

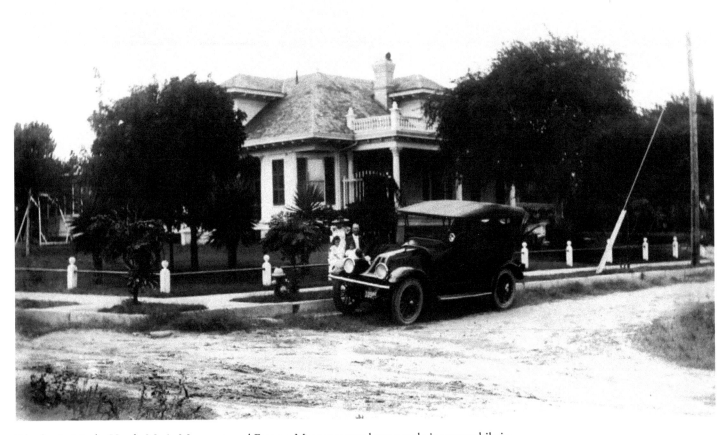

Charles A. Meuly, Ursula Marie Magnerat, and Frances Magnerat stand next to their automobile in front of their home on Blucher and Carrizo streets. Charles Meuly was the son of Conrad Meuly, who arrived in Corpus Christi in 1850. He was a survivor of the Mier Expedition, a raiding party responding to the Dawson Massacre and captured by the Mexican Army on Christmas Day, 1842. The men were forced to draw beans to see who would be executed. Conrad Meuly was among the lucky ones who drew a white bean instead of a black one.

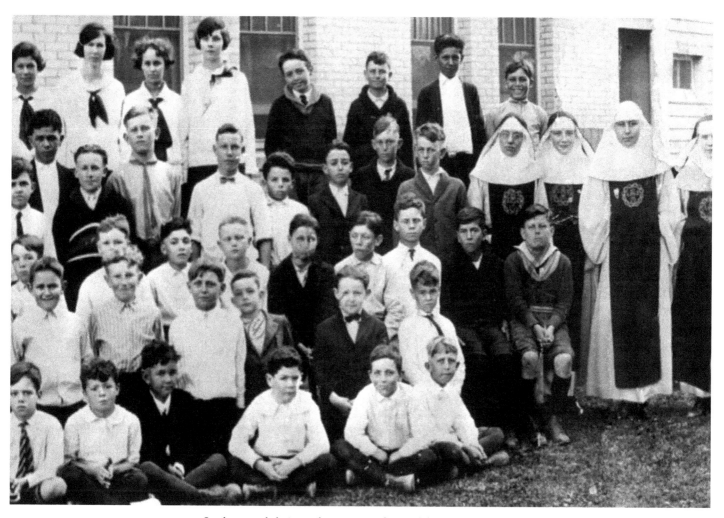

Students and their teachers pose in front of the Incarnate Word Academy. The Sisters of the Incarnate Word and Blessed Sacrament arrived in Corpus Christi in 1871. They soon bought property surrounded by Leopard, Carancahua, Antelope, and Tancahua streets where they constructed the building seen here. This building would be moved in 1926 to make room for a bigger brick structure to accommodate the growing student population.

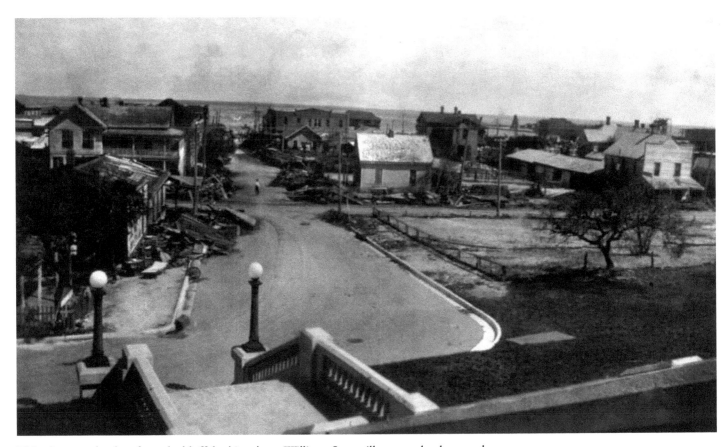

This photograph taken from the bluff, looking down Williams Street, illustrates the damage the downtown area suffered from the 1919 hurricane. Debris lines the streets, many homes are missing, and others are unstable because of the excessive wind and rising water that pummeled the city.

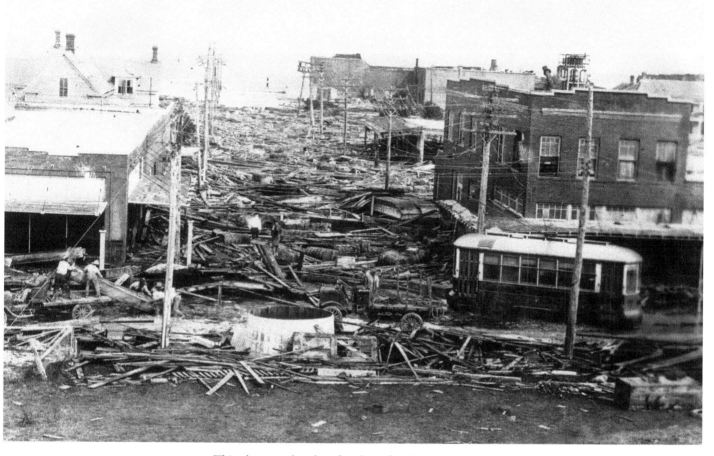

This photograph, taken five days after the surprise hurricane of 1919, exposes the havoc the storm wreaked on the city. W. E. Breman (white shirt, at center) stands in the middle of Laguna Street peering at the wreckage while men on Mesquite Street load lumber onto a truck. An electric trolley sits idle in the aftermath of one of the worst hurricanes ever to hit Corpus Christi.

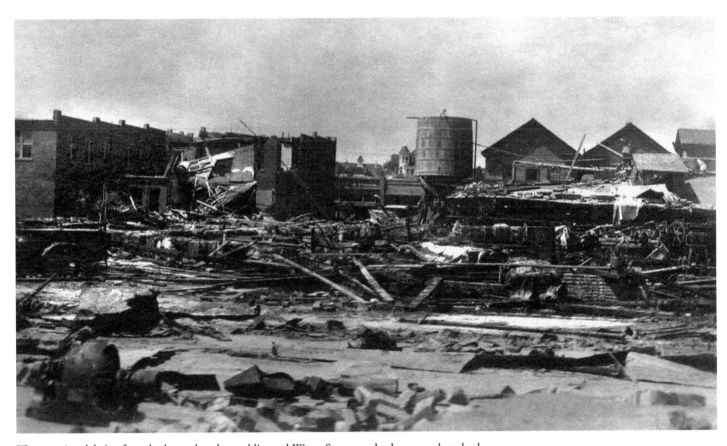

The massive debris of crushed wood and metal littered Water Street, and salvage workers had a difficult time clearing the area. The National Guard arrived in Corpus Christi to aid in restoring order and help with the cleanup.

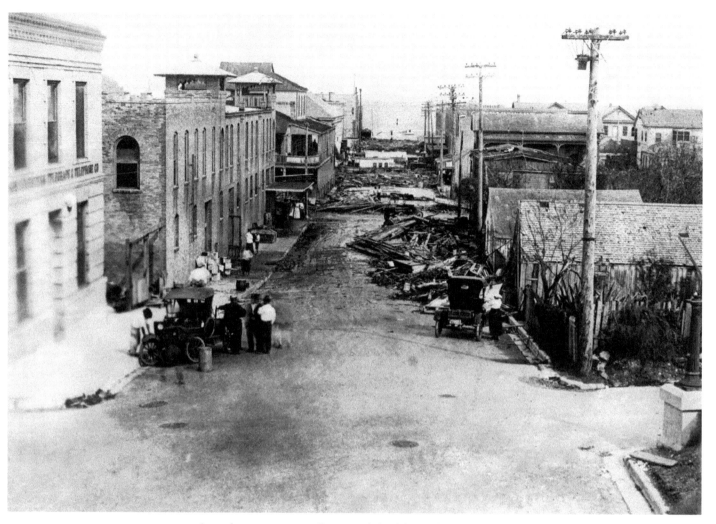

Several men are seen walking amid the debris left by the storm surge of the 1919 hurricane, searching for the deceased. This storm claimed an unknown number of lives; many victims were never found. A stone monument in Rose Hill Cemetery commemorates those lost in this storm.

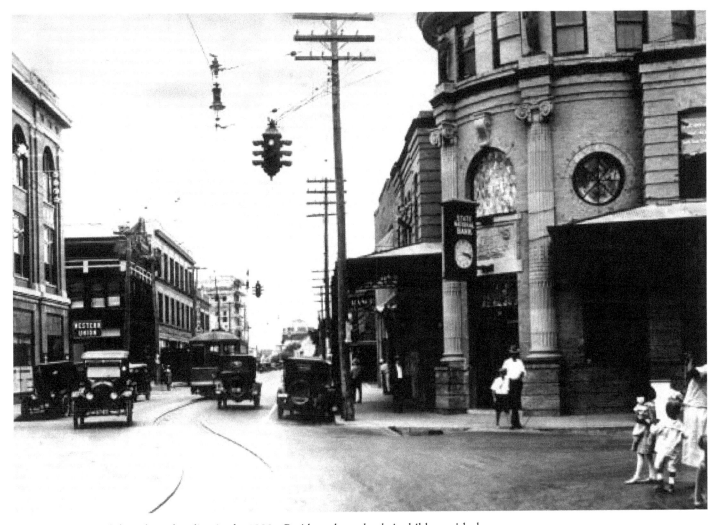

Mesquite Street at Schatzel was bustling in the 1920s. Residents brought their children with them to shop along this thoroughfare. The building to the right is the First State Bank, designed by Mayor Dan Reid in 1908. The bank changed ownership several times, and by 1922 it was known as State National Bank, which merged with Corpus Christi National Bank in 1956.

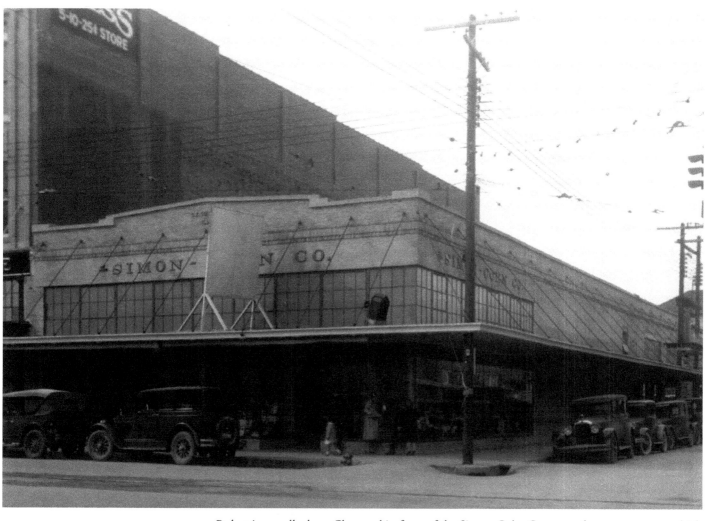

Pedestrians walk along Chaparral in front of the Simon-Cohn Company department store, which opened by 1924 and operated for at least the next ten years. To the left of this building is the Kress Five and Dime Store, which opened in 1916 and weathered several big storms and hurricanes. This stable city fixture closed its doors 75 years later in 1991.

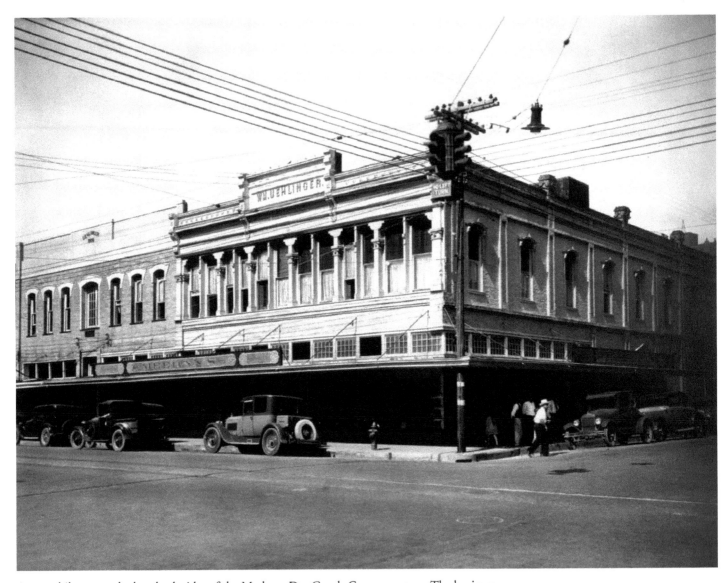

Automobiles are parked on both sides of the Meehans Dry Goods Company store. The business operated out of this location at 515 Chaparral in the Uehlinger Building from at least 1924 to 1932.

The Making of a Modern City

(1926–1939)

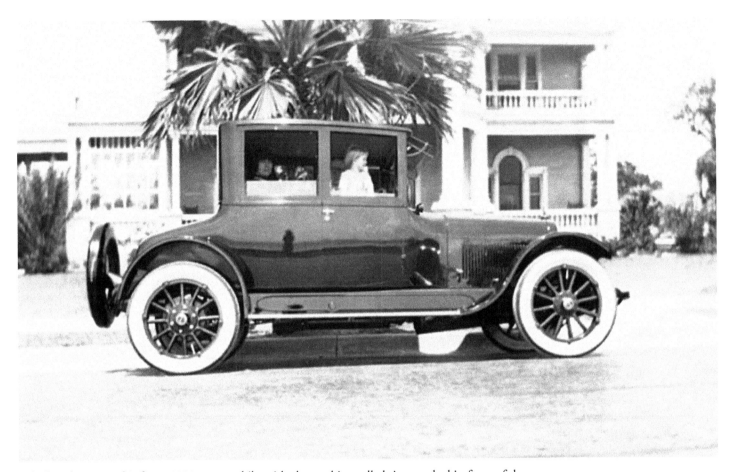

A little girl waits in this fancy 1920s automobile, with clean, white-walled tires, parked in front of the
W. W. Jones building at 511 South Broadway. The home was built in 1905, and Jones and his family
lived there until 1938. The city also used this building from 1935 to 1955 as a library.

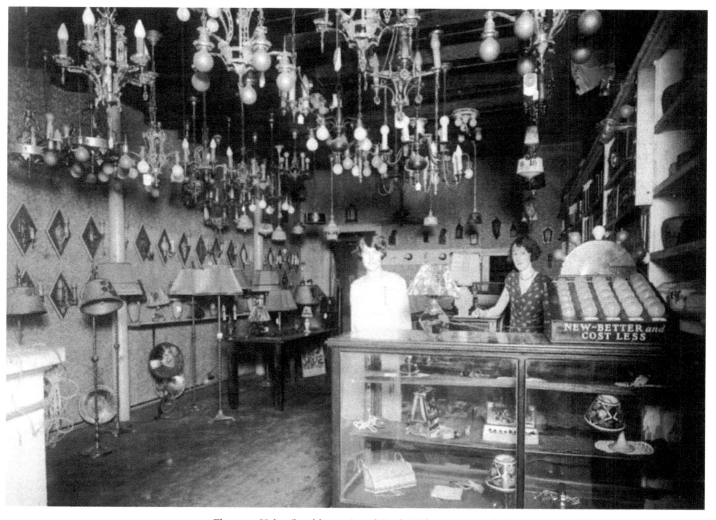

Florence Kaler (bookkeeper) and Freda Kaler (stenographer) stand behind the counter, surrounded by lights, lamps, and other fixtures adorning the inside of the Smith Electric Company. The building located at 619 Mesquite opened for business around 1926 and operated at this location until 1939.

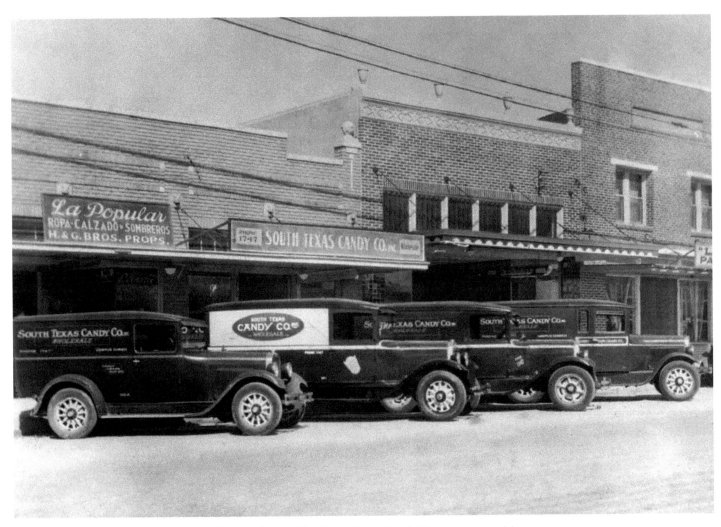

The delivery cars parked along Leopard Street in front of the South Texas Candy Company are waiting
to deliver their goods. This business, established around 1928, produced several different sweets for
the growing Corpus Christi area.

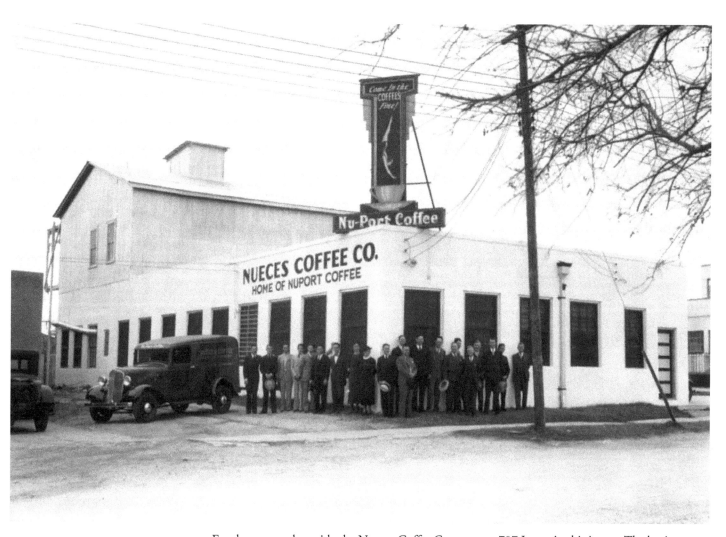

Employees stand outside the Nueces Coffee Company at 707 Lester in this image. The business was established in 1929 with Sam Beilin as president, W. E. Bivens as vice-president, and Sam Charles as secretary-treasurer.

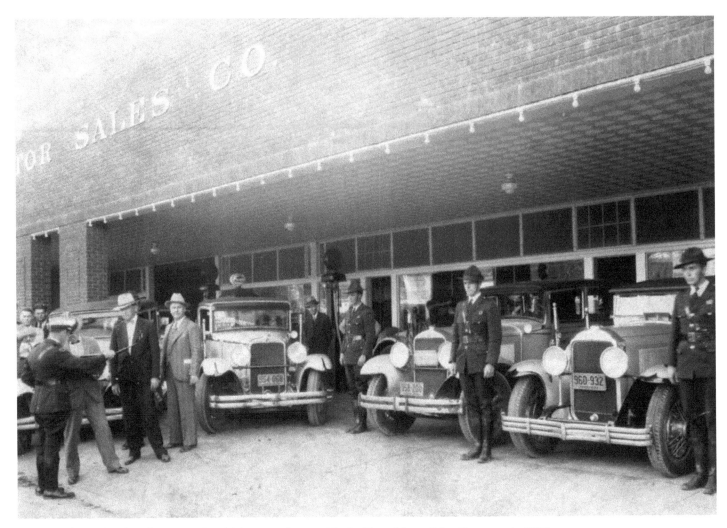

Automobiles are lined up for a B. F. Goodrich promotion outside the Texas Motor Sales Company in 1929.

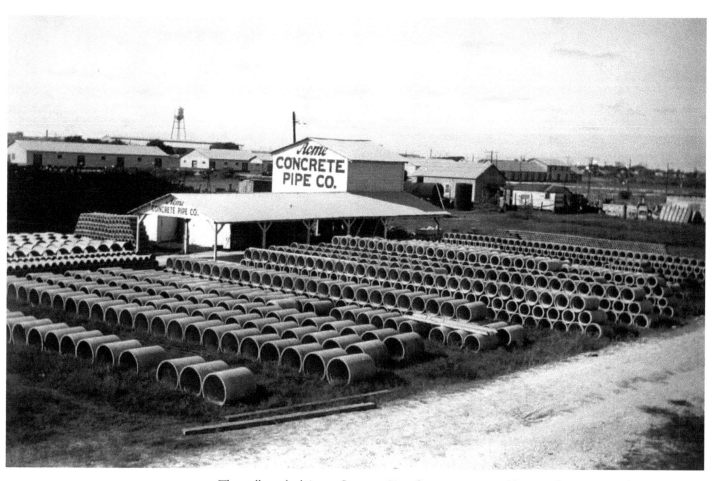

The well-stocked Acme Concrete Pipe Company, operated by Russel Lyons & Carl Henny at 501 Doss, provided pipe and other fixtures to the growing city in 1935.

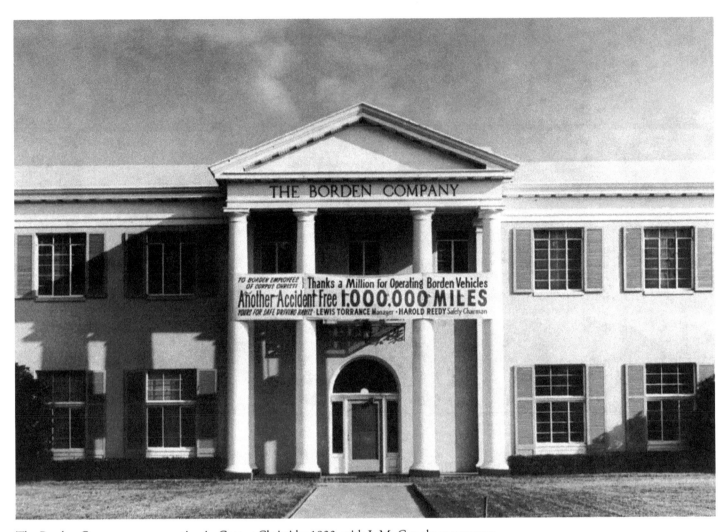

The Borden Company was operating in Corpus Christi by 1933, with J. M. Conoly as manager. Located on the corner of Waco and Blucher streets, it was one of two milk processing plants in the city. The other was Hygeia, which operated in conjunction with Knolle Farms.

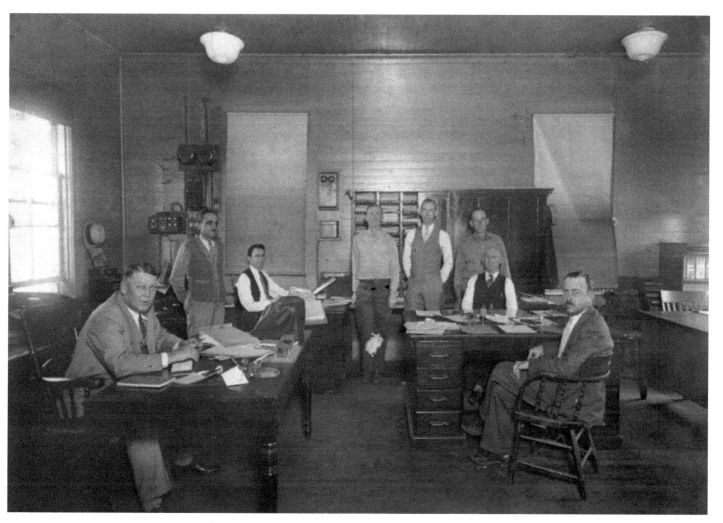

This was the 1934 office of the Southern Pacific Railway freight station located on Belden and Power streets. The clerks in the picture are identified, left to right, as George Gould (agent), Jimmy Brooks (chief clerk), Ed Beasley (telegrapher), Dick Leahy (yard clerk), Deacon Saunders (clerk), D. R. Prince (round house), A. Patrick (assistant agent), and Jack Cheaney (rate clerk).

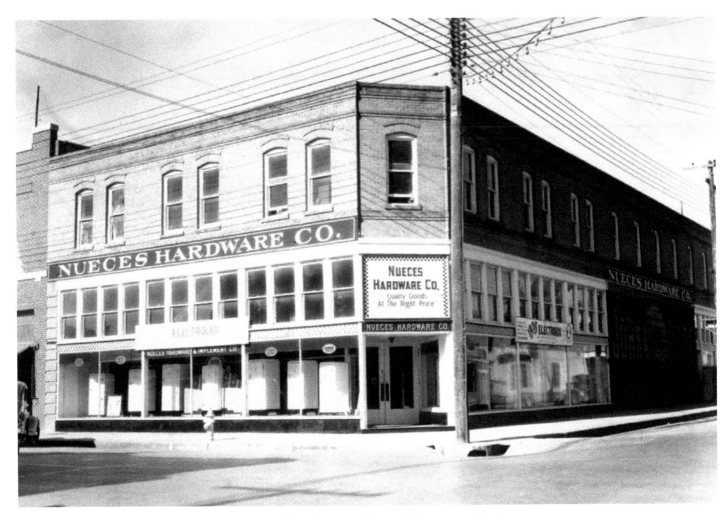

This photograph of the Nueces Hardware Company, located at 323 Chaparral Street, was taken in 1935. The business had operated at this location since at least 1927.

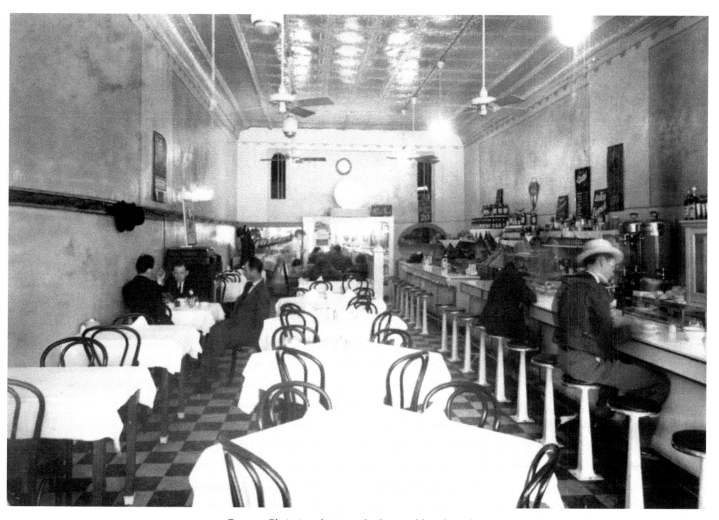

Corpus Christi at this time had several hotels and restaurants that catered to businessmen. These patrons are enjoying their lunch at a local restaurant.

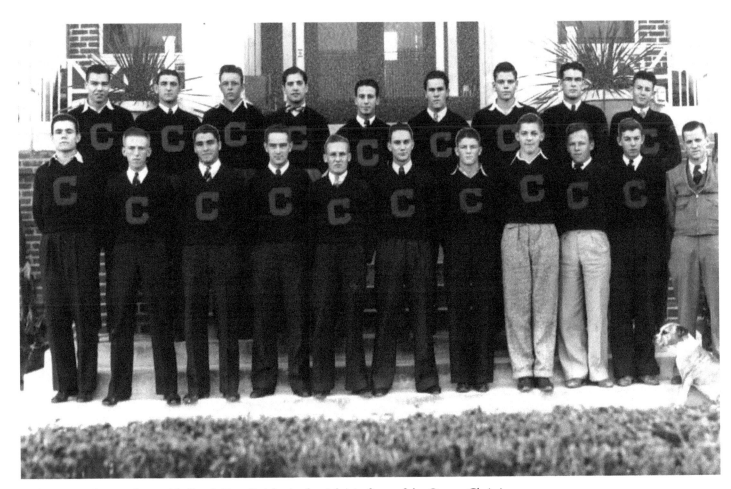

A class in 1936 poses along with Coach Tom Quigby (at far-right) in front of the Corpus Christi Academy.

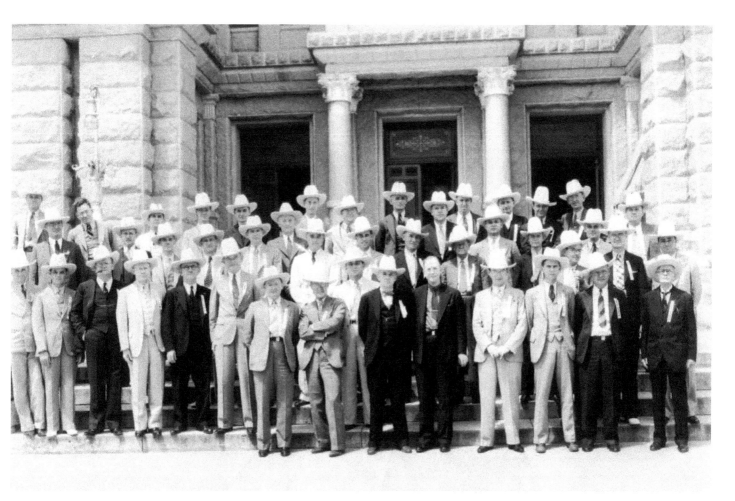

This picture documents the 45 members of the Corpus Christi Kiwanis Club who traveled to Austin for a meeting in 1936.

This four-story building, opened by Clark Pease on Chaparral and Peoples streets, is the City National Bank. Pease arrived in Corpus Christi in 1904 and opened a small bank, but soon after merged with a national entity to form the City National Bank. The bank operated at this location until 1938, when the Corpus Christi National Bank moved to this area.

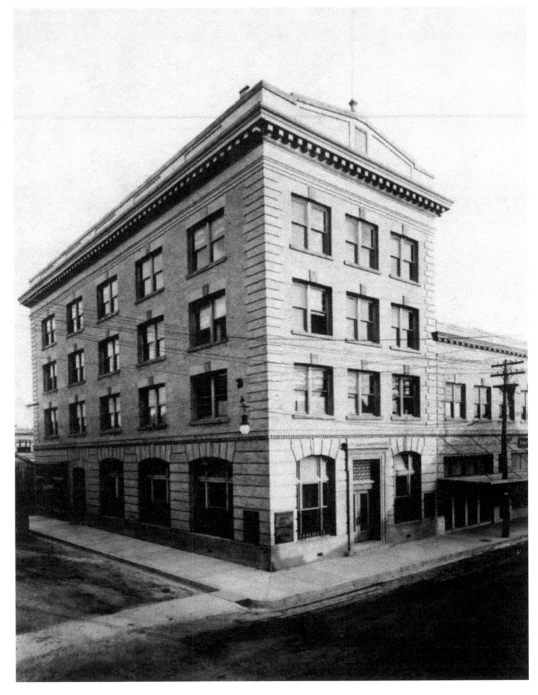

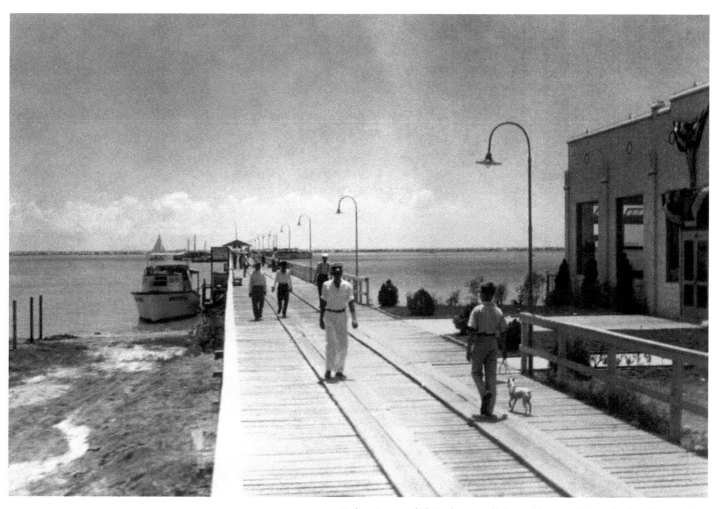

Pedestrians and their dogs stroll down Pleasure Pier, enjoying the weather.

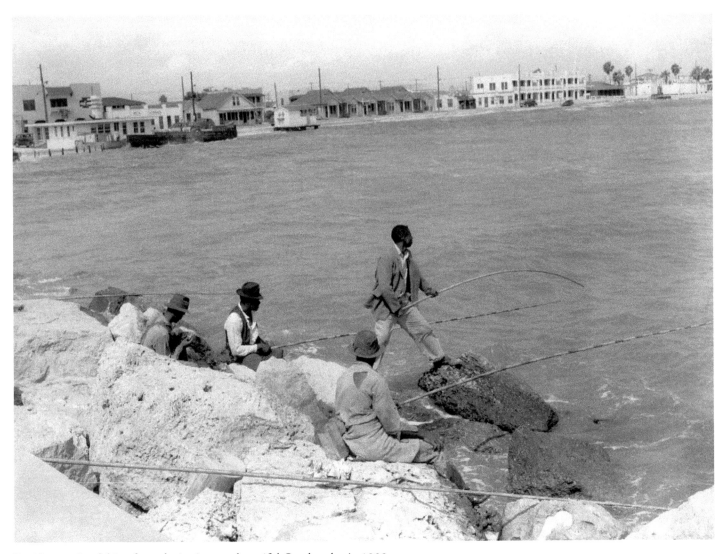

Residents enjoy fishing from the jetties on a beautiful October day in 1939.

In 1939, Corpus Christi had at least 10 different shoe stores and 20 shops to repair shoes.

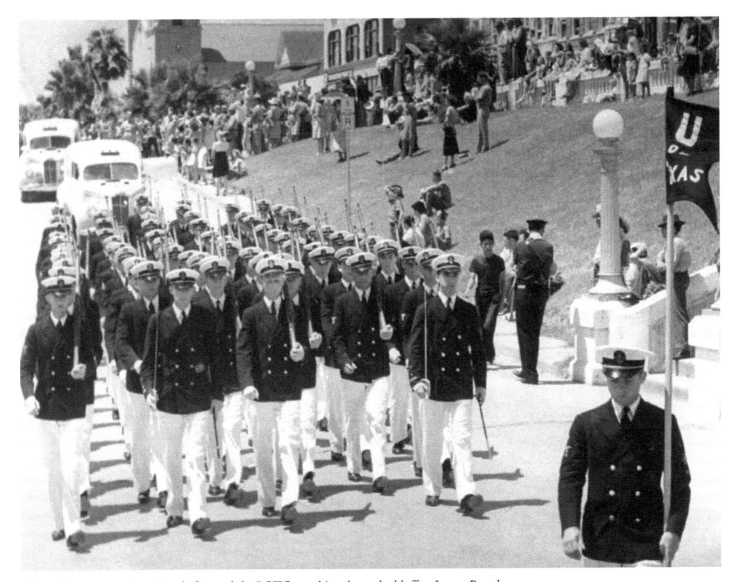

The 1941 Buccaneer Days Parade featured the ROTC marching down the bluff to Lower Broadway. This parade had its origins in celebrating Spanish explorer and mapmaker Alonso Alvarez de Pineda's visit to the area in 1519 as part of his assigned task of mapping the Gulf Coast from Florida to Mexico for the governor of Jamaica. The first parade, held on June 3, 1938, featured a Spanish galleon anchored to the breakwater and a discovery reenactment of Pineda's first step onshore. This event has been a leading attraction in the city since its debut.

War Years and Aftermath

(1940–1949)

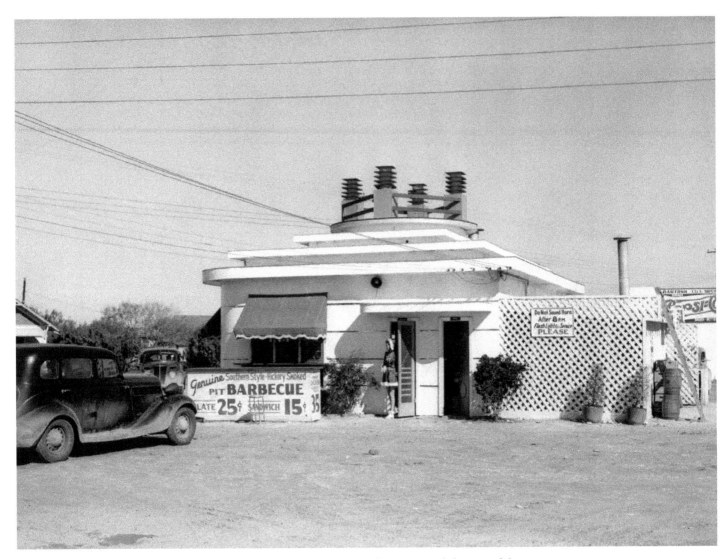

This drive-in sandwich shop built near the construction site of the Naval Air Station fed many of the construction workers, as well as those employed at the base.

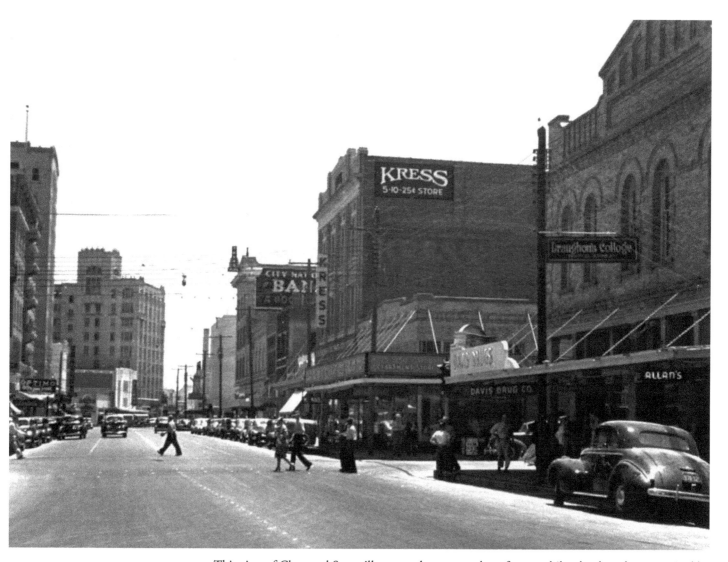

This view of Chaparral Street illustrates the vast number of automobiles that have been acquired by residents of the town. The building on the right in the foreground is Draughons Practical Business College. Many women attended this school to learn clerical skills, which allowed them to take advantage of the new employment opportunities being created in the Corpus Christi area.

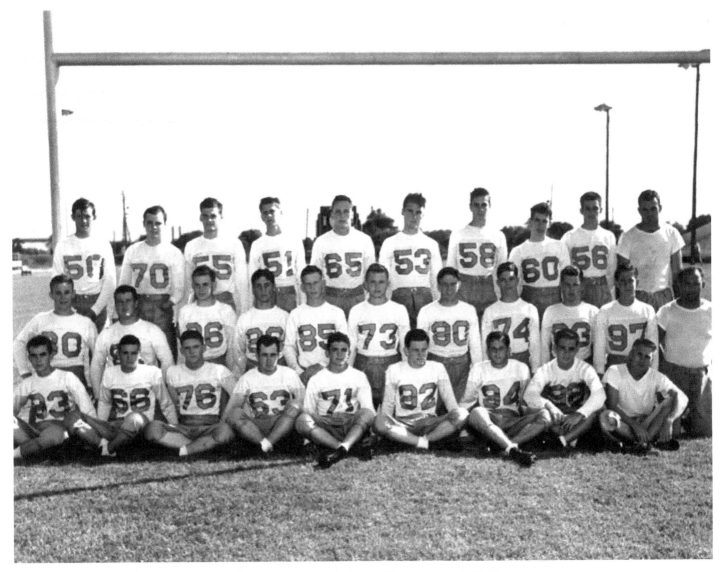

The Corpus Christi High School Buccaneer football team poses in front of the goal posts in 1941.

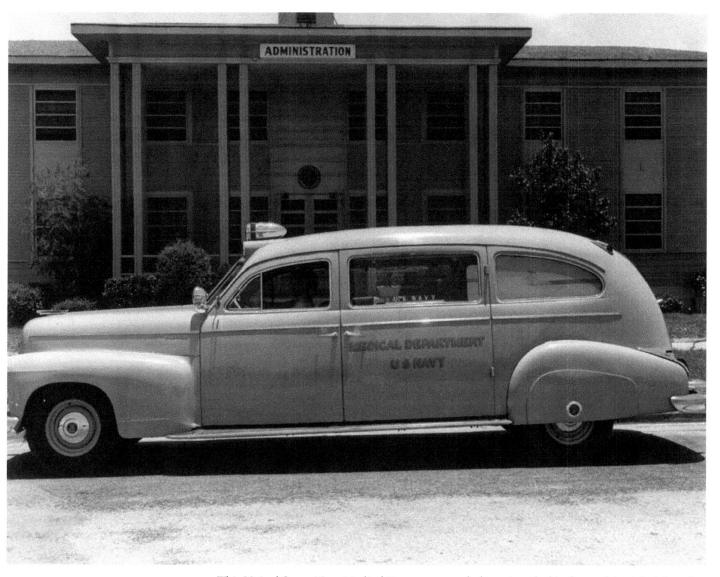

This United States Navy Medical Department ambulance is parked in front of the Administration Building at the Naval Air Station. Construction for the Administration Building began in 1940. It was the first structure completed on the base.

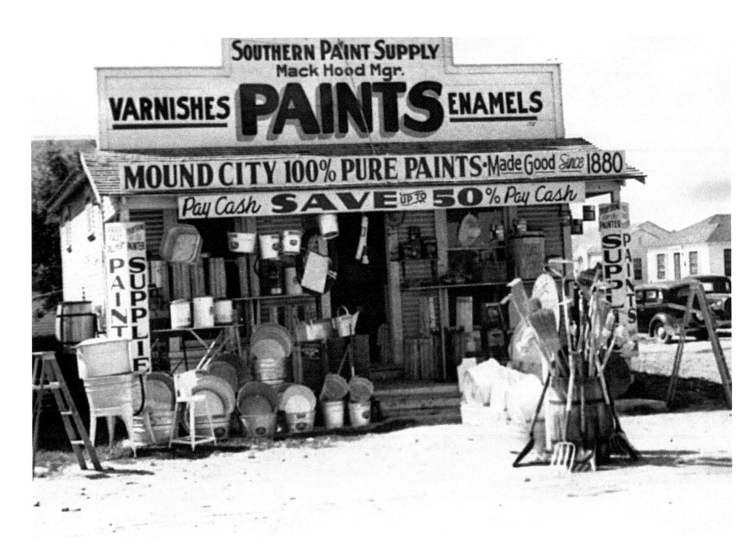

This wooden building housed the Southern Paint Supply business at 1602 Ayers, managed by Mack Hood. The company sold various paints and supplies, including tools and household items.

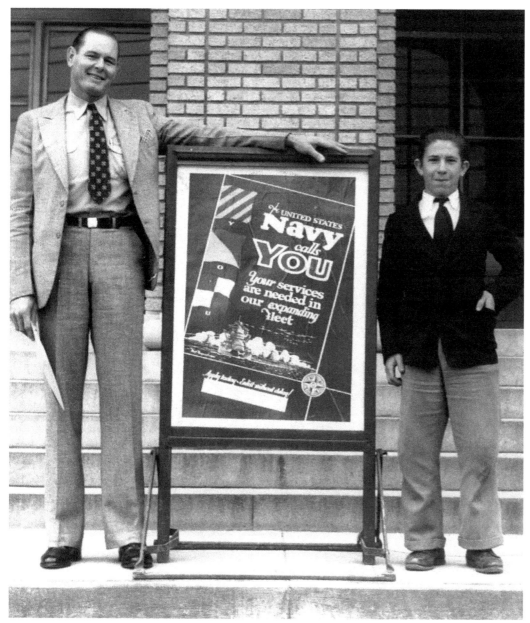

This photograph pictures a Navy advertisement taken right after Christmas in 1941. Since the coming of the Naval Air Station to Corpus Christi, the community has strongly supported this segment of the armed services.

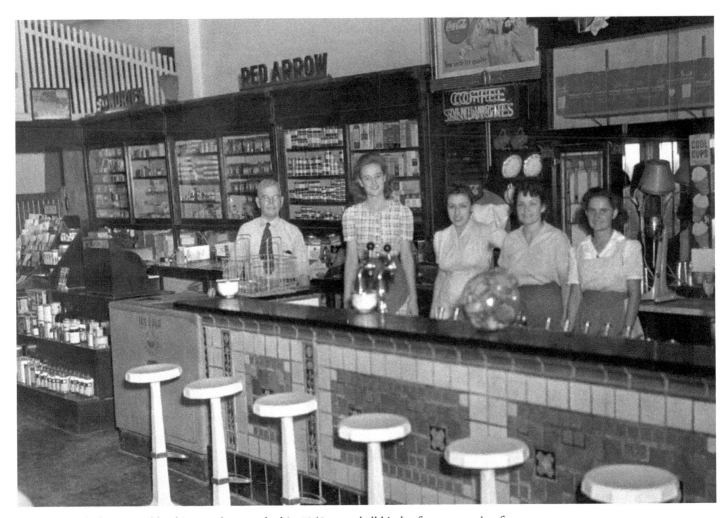

Drugstore soda fountains, like this one photographed in 1943, served all kinds of treats, ranging from coffee and sandwiches to ice cream and other delicacies. They were popular social meeting places for both youths and adults in Corpus Christi.

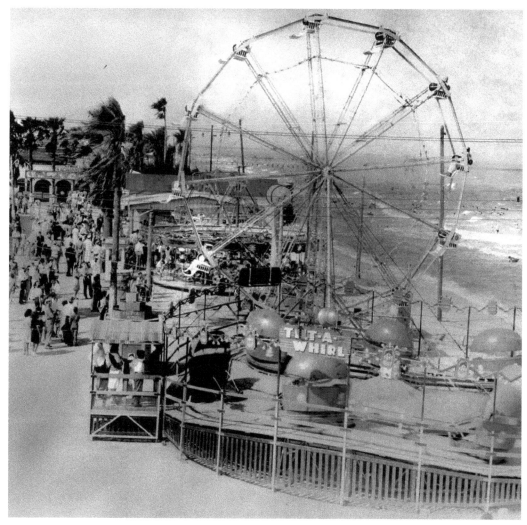

This amusement park on North Beach in 1942 drew crowds, especially the servicemen from the Naval Air Station, to ride the Tilt-A-Whirl, carousel, Ferris wheel, and the like. If the rides weren't enough fun, visitors could go for a swim and dive into the saltwater pool. Crowds were especially numerous during holidays and special events such as air shows, beauty contests, and boat shows.

A pilot stands beside his plane.

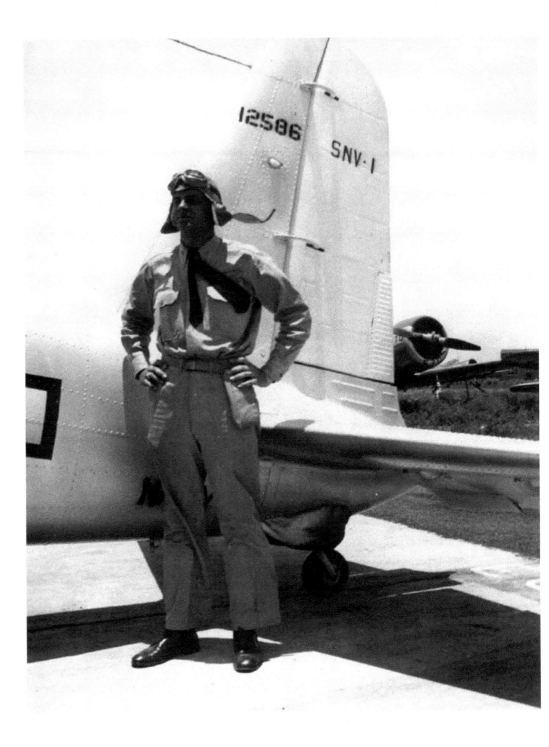

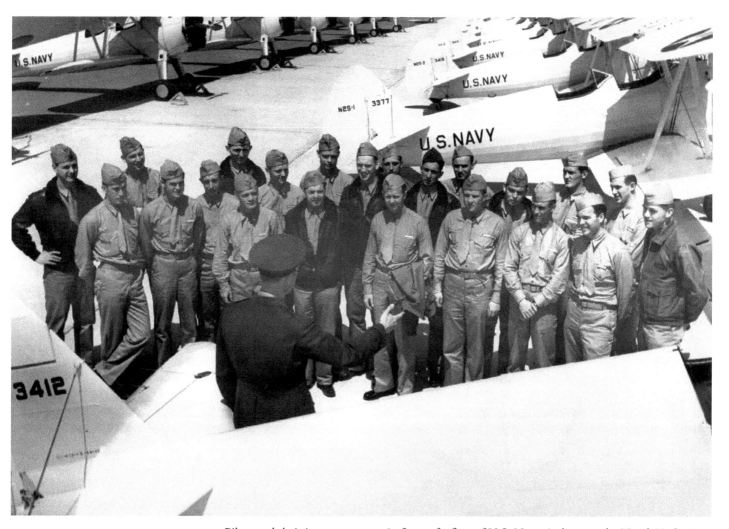

Pilots and their instructors pose in front of a fleet of U.S. Navy airplanes at the Naval Air Station. Two-seater biplanes like these were generally used for training purposes in World War II.

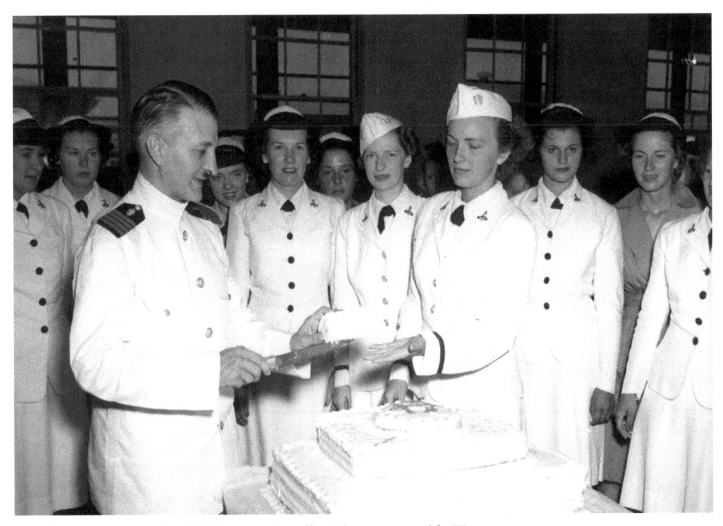

WAVES are enjoying some cake with their commanding officer. The acronym stood for Women Accepted for Volunteer Emergency Service, a division of the U.S. Navy during World War II.

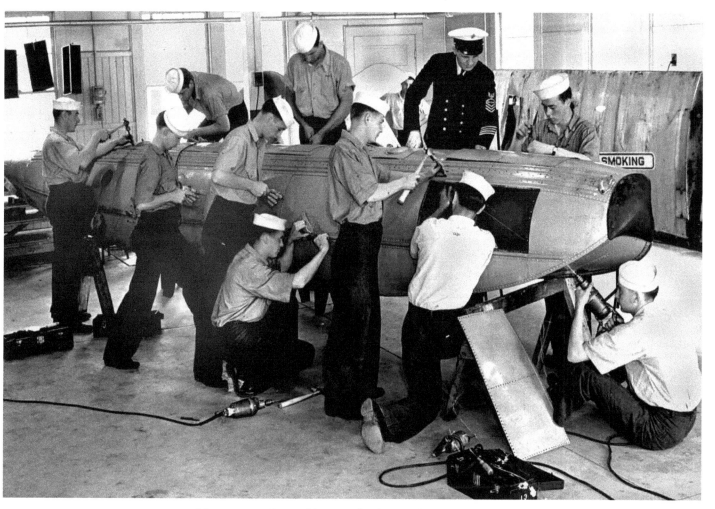

Navy personnel assemble part of a plane under the watchful eye of an officer at the Naval Air Station.

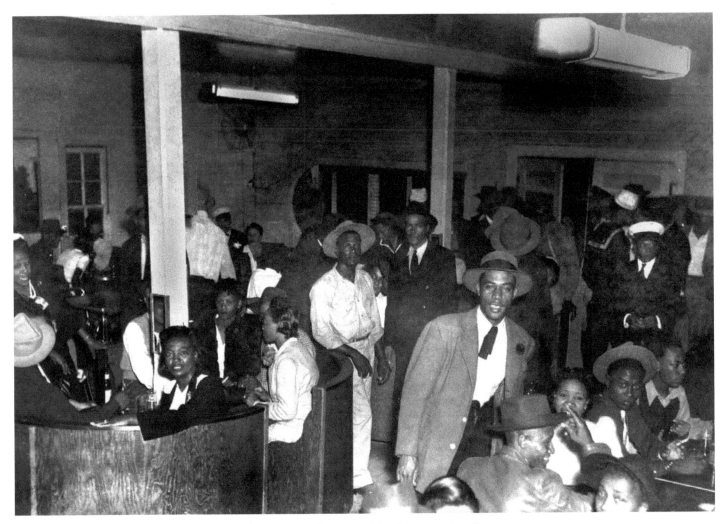

Sailors and civilians alike relaxed and enjoyed themselves in the many clubs that popped up in town during the war years.

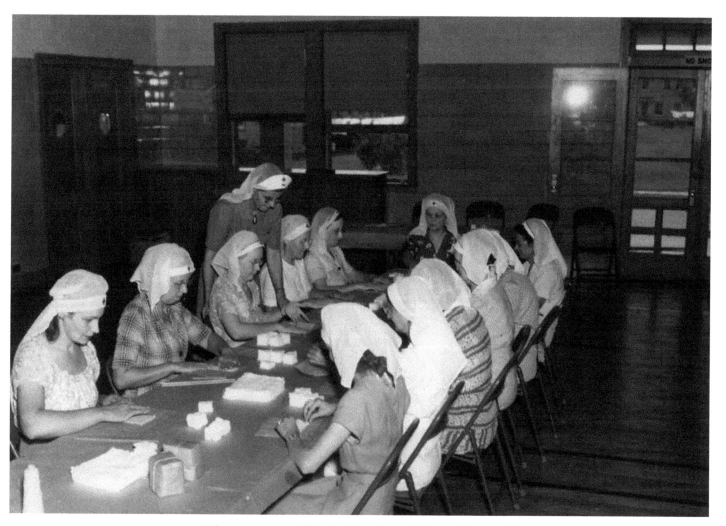

Volunteer women of the Red Cross in 1944 helped the war effort by assembling first-aid kits; knitting scarves, gloves, and socks; and sewing various garments for members of the armed services. During this time the organization also attracted nurses to teach first aid to the police department and to civilians. They also worked at the naval hospital and helped many during the hurricane of 1942.

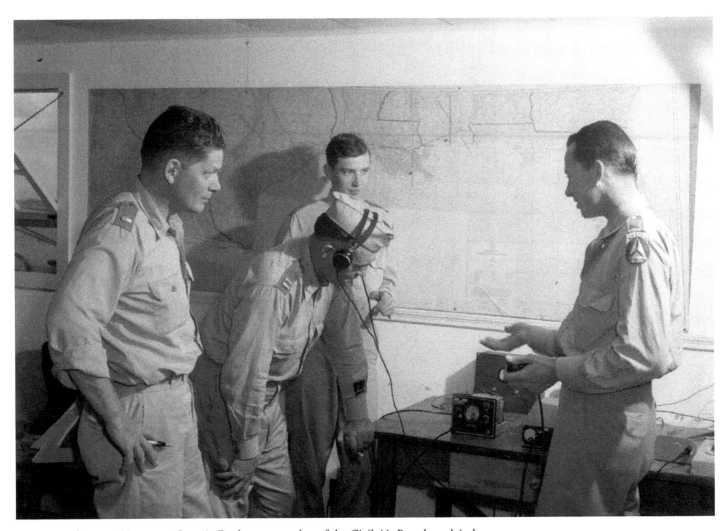

Servicemen listen to Lieutenant Ronnie Durham, a member of the Civil Air Patrol, explain how to use the radio telephone equipment.

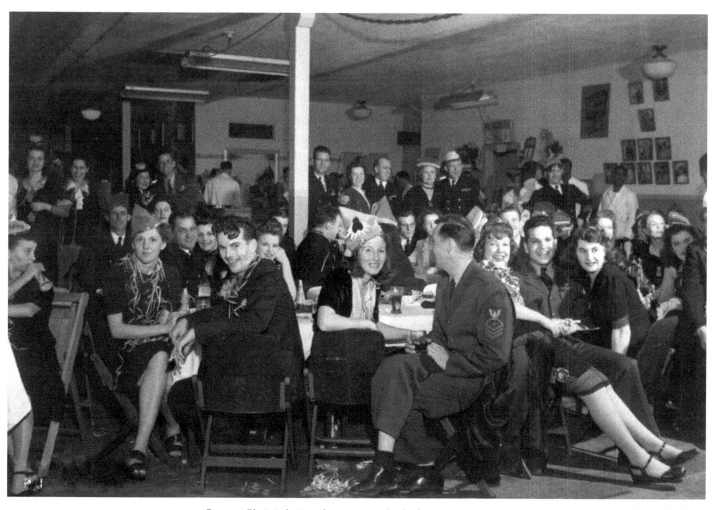

Corpus Christi during the war years had a large temporary population because of the Naval Air Base. Entertainment arenas sprang up all over the city, including theaters, dance halls, and clubs.

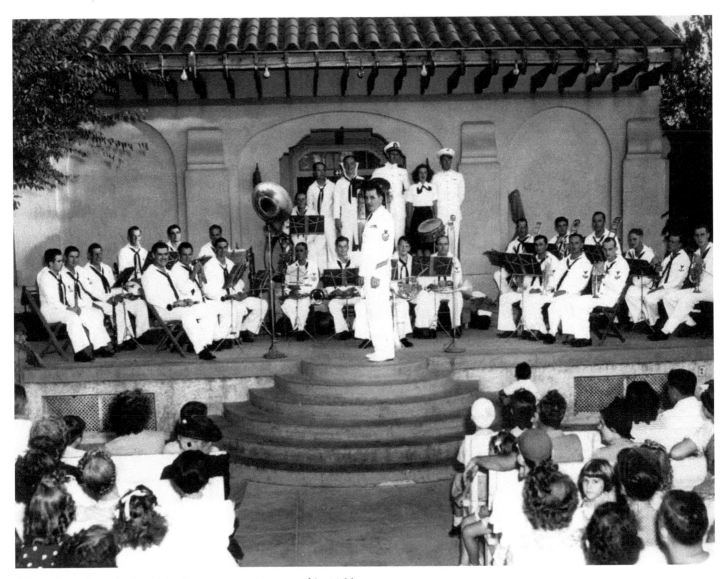

A Navy band from the Naval Air Station entertains a crowd in 1944.

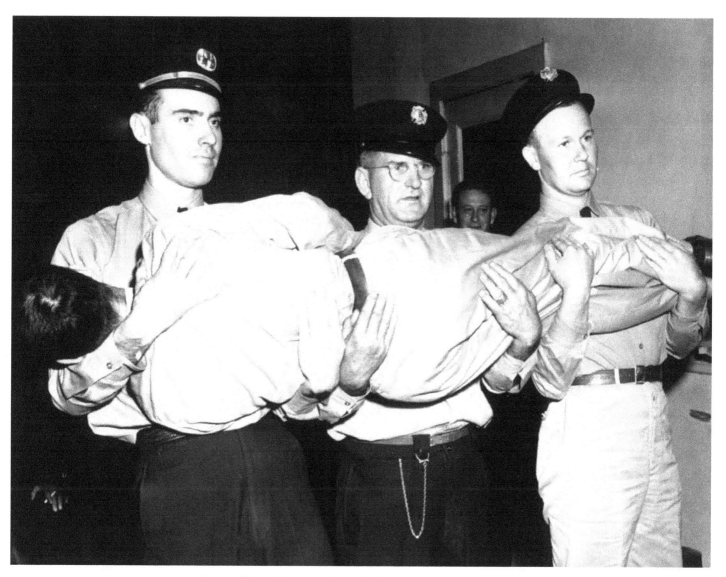

Corpus Christi firemen John Carlisle, Watt Cooper, and A. O. Gibson demonstrate lifesaving practices to other members of the fire department. Victor Garrott volunteered to be the "victim" for this demonstration.

This view of Upper Broadway to the north highlights the city's tallest buildings in the 1940s. In the foreground is the Nixon Building. Across the street is the Plaza Hotel, and next to it is the Driscoll Hotel.

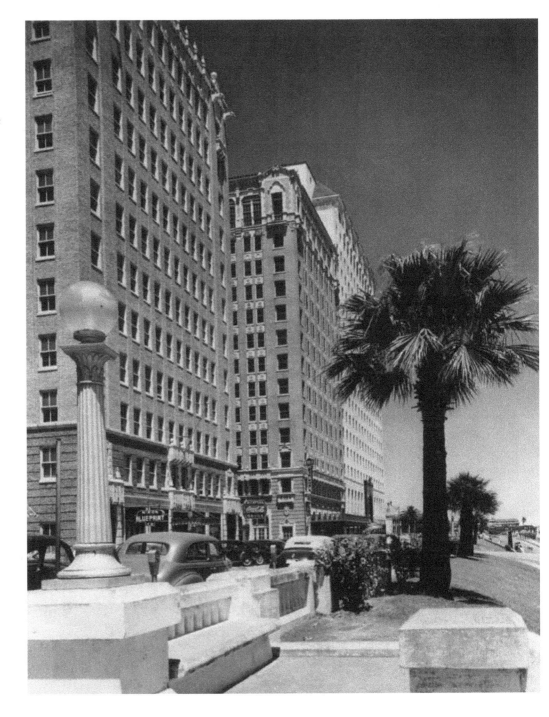

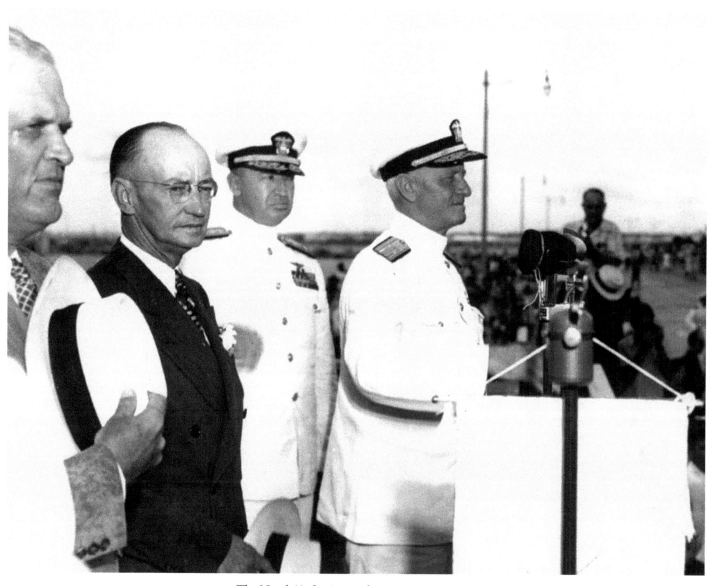

The Naval Air Station undergoes an inspection on June 18, 1946, with Admiral C. W. Nimitz presiding. Mayor Robert Wilson, Tom Graham, and Admiral Jocko Clark join Nimitz onstage for the ceremonies.

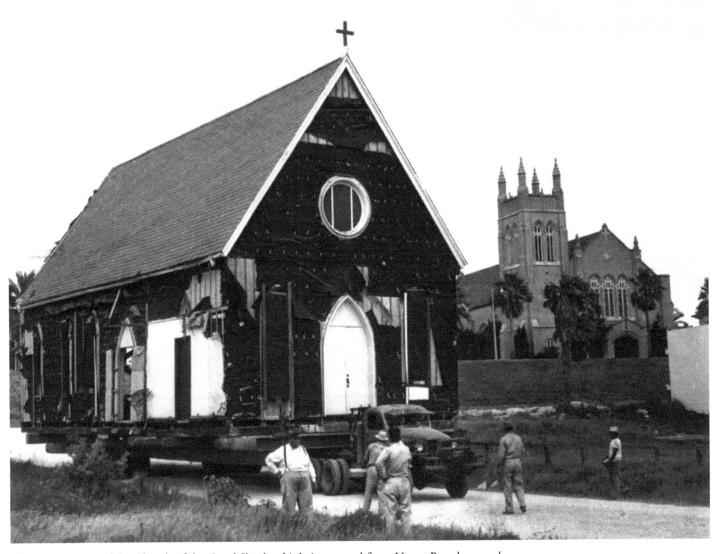

The main section of the Church of the Good Shepherd is being moved from Upper Broadway and
Park to its new location on Staples Street in 1949. This Episcopal Church, one of the oldest churches
in the city, was organized in 1874. Two years later, New York architect Richard Upjohn built this
Gothic structure on the corner of Chaparral and Taylor. In the background is the First Presbyterian
Church.

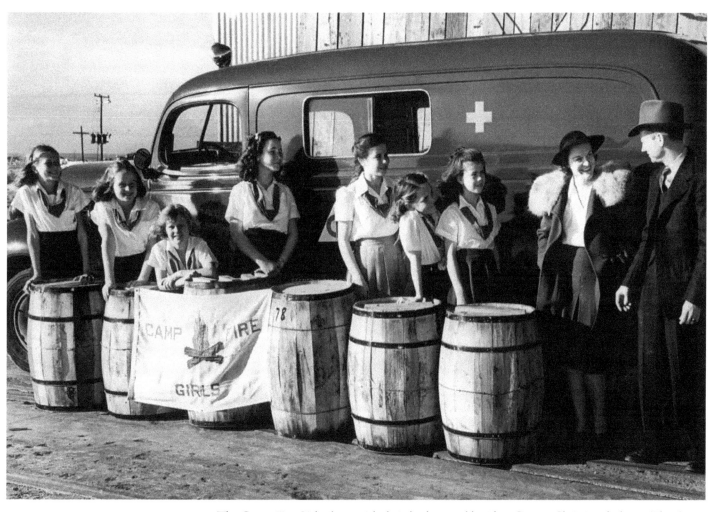

The Camp Fire Girls along with their leader stand beside a Corpus Christi ambulance. The Camp Fire Girls, founded in 1910 in Vermont by Luther Gulick, M.D., and Charlotte Gulick, grew rapidly throughout the United States. By 1912, the organization was incorporated, and many large cities including Corpus Christi would have a club.

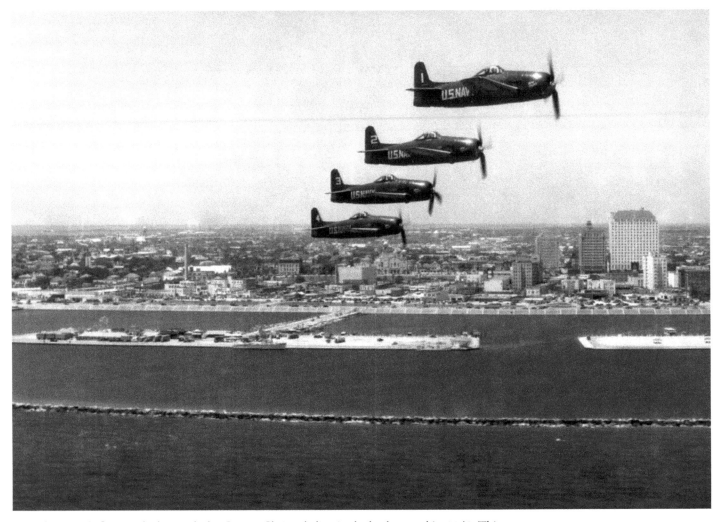

The Blue Angels fly over the bay with the Corpus Christi skyline in the background in 1949. This group of Navy flyers still entertains the public with their flying skills and intricate aerial maneuvers.

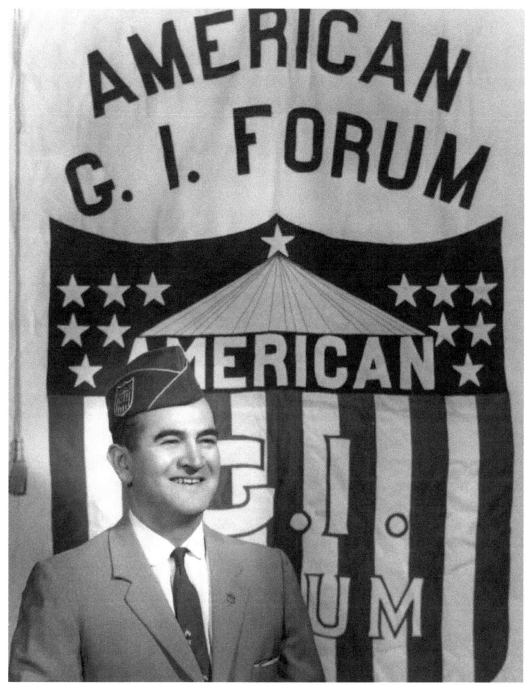

Hector P. Garcia stands in front of the American G. I. Forum flag. This organization, originally formed to protect Mexican American veterans' rights, began in Corpus Christi in 1948, with Garcia as chairman. By 1949, it had become a statewide organization and soon expanded its scope to fight discrimination wherever it was found.

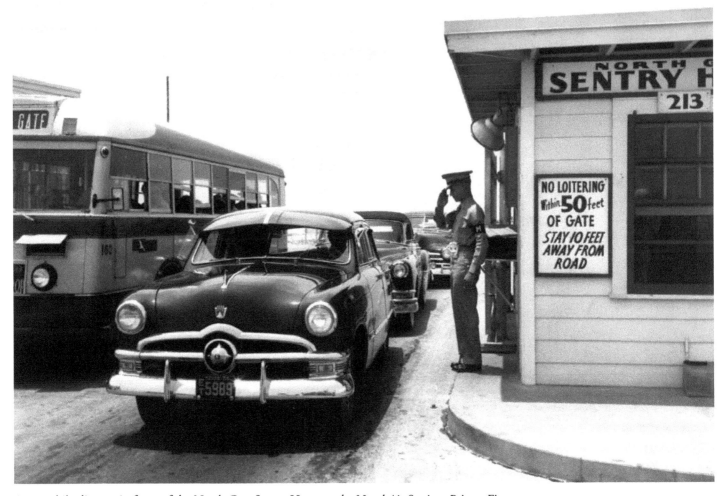

Automobiles line up in front of the North Gate Sentry House at the Naval Air Station. Private First Class N. J. Dyess with the United States Marine Corps salutes the first visitor onto the Naval Air Station for an Armed Forces Day celebration.

THE GROWING METROPOLIS

(1950–1960s)

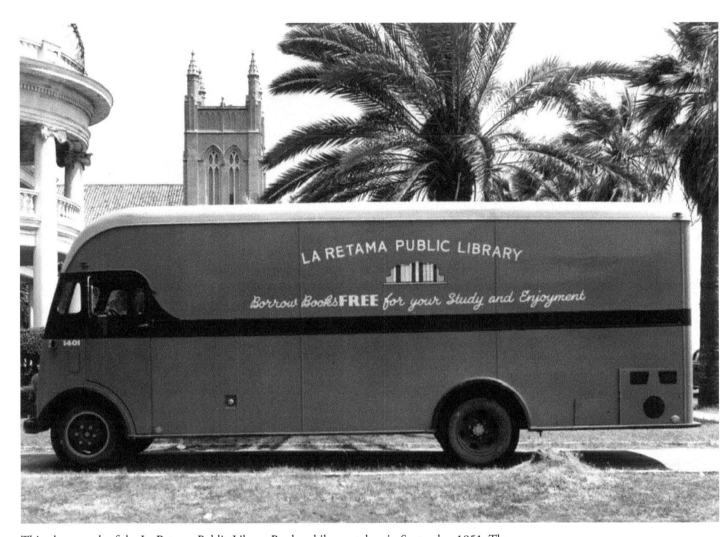

This photograph of the La Retama Public Library Bookmobile was taken in September 1951. The bookmobile contained shelves with awnings that opened and closed for ease of access as well as travel. This vehicle brought library services to the public and later had a regular school route. The building to the front of the vehicle is the W. W. Jones home, which housed the library until 1955.

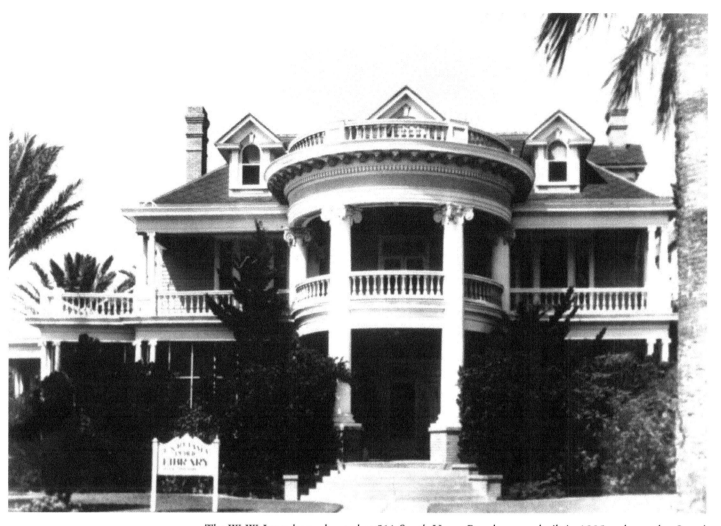

The W. W. Jones house located at 511 South Upper Broadway was built in 1905 and served as Jones' residence until his death. The building was purchased in 1937 to house the library. The La Retama Public Library remained at this location for 18 years, but in 1955 the library moved into a larger and more modern facility (old city hall) at the corner of Mesquite and Peoples streets.

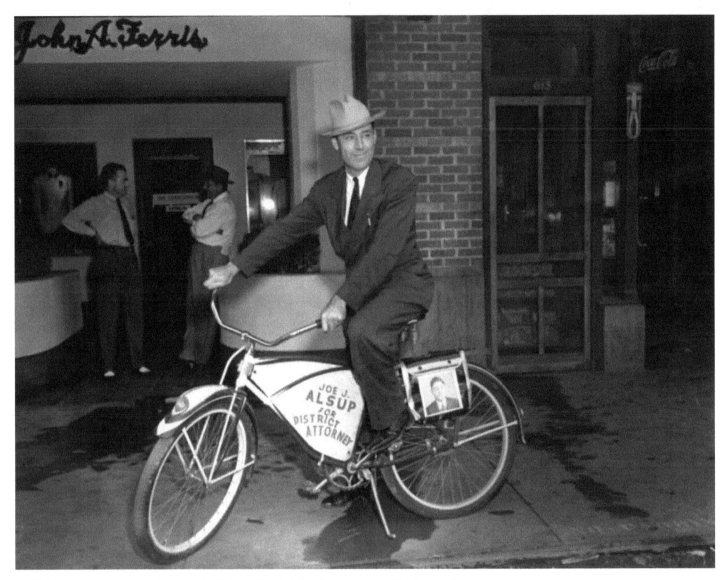

Joe J. Alsup stops to pose in front of the John A. Ferris Men's Wear shop at 611 Leopard as he campaigns on his bannered bicycle for the position of district attorney.

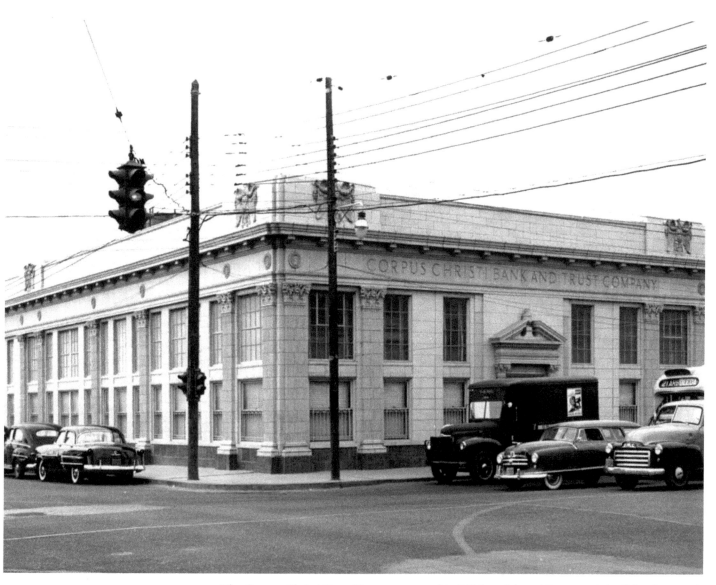

The Corpus Christi Trust Company opened in 1928 on Schatzel Street, and the following year it moved up the hill and changed its name to the Corpus Christi Bank and Trust. The bank continued to expand and purchased this building located on Leopard and Tancahua streets, formerly owned by Perkins Brothers Department Store. The bank remained at this location until 1982 when it moved to the Bank and Trust Plaza.

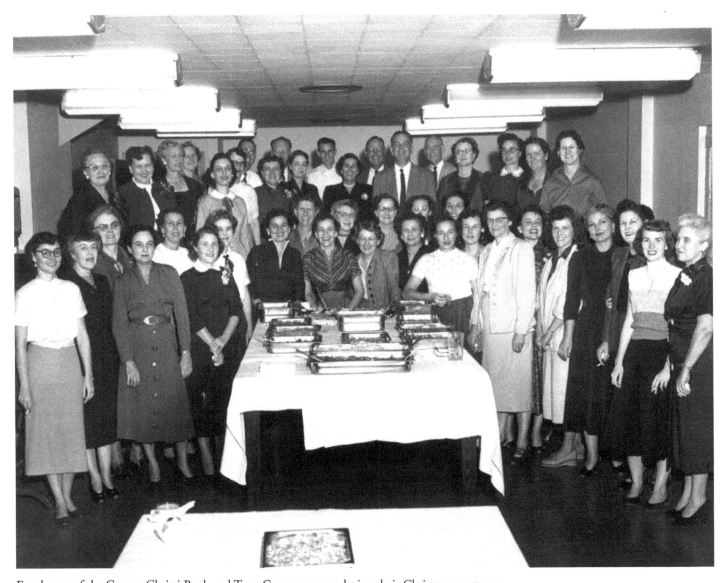

Employees of the Corpus Christi Bank and Trust Company pose during their Christmas party on December 16, 1954.

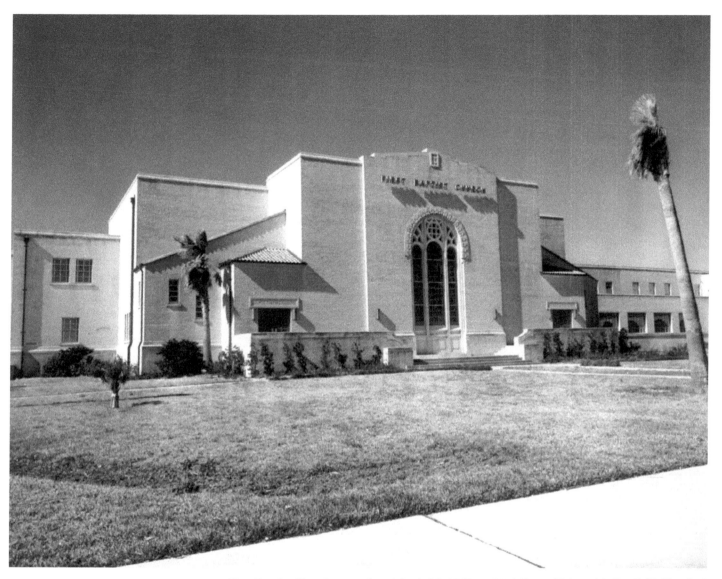

First Baptist Church opened on March 26, 1950, at 3115 Ocean Drive with Dr. C. E. Hereford as pastor. The building had an auditorium for 1,200 and an educational building with classrooms. The building was later enlarged in 1967 with a new addition containing a sanctuary and an elevated amphitheater. The original church, formed in 1878, was one of the oldest churches in the area.

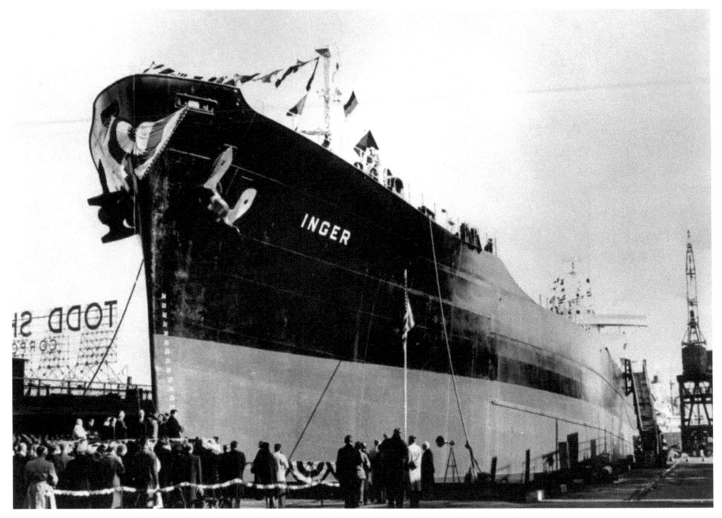

A crowd gathers on the platform where the *Inger* docks at a wharf in the Corpus Christi ship channel.

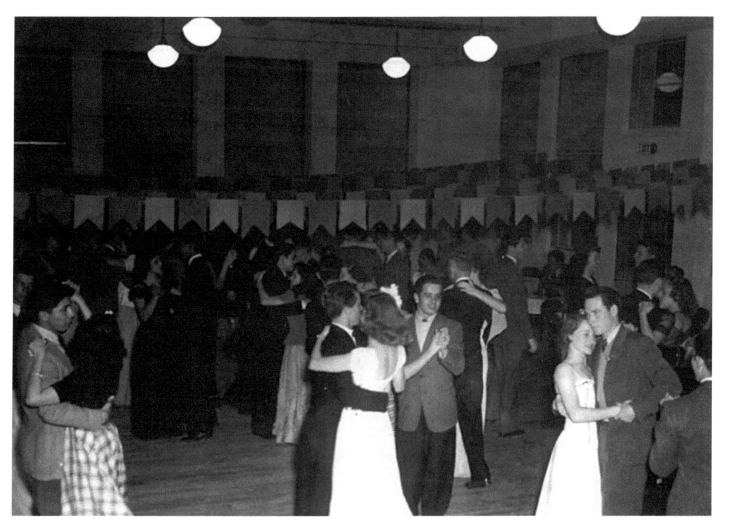

Students dance the night away at a Del Mar College affair.

Construction is under way for the Harbor Bridge in 1956. This new structure would take the place of the 1926 Bascule Bridge, which could not accommodate larger ships entering the port because of its limited 97-foot-wide opening. The Harbor Bridge construction, completed on October 23, 1959, allowed vehicles to cross the ship channel with ease and added a new feature to the bayfront view.

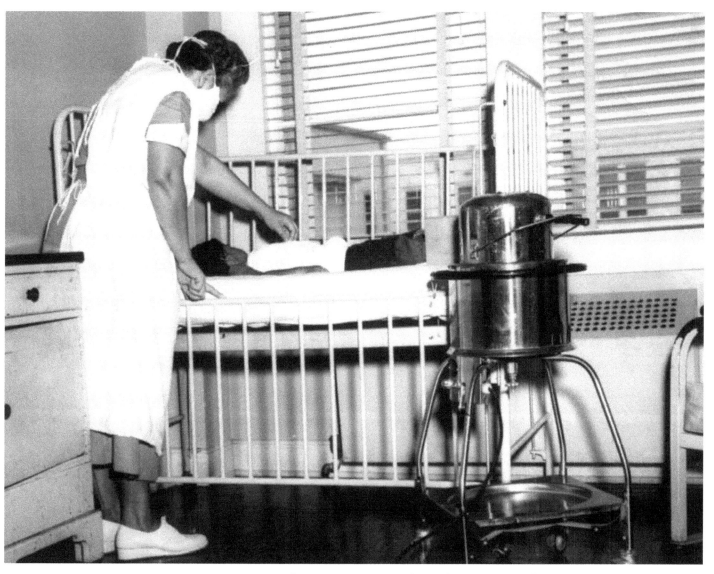

A nurse cares for a young patient in a hospital room. In the early 1950s, Corpus Christi had nine hospitals including the U.S. Naval Hospital; Spohn Hospital, which opened in 1923; Memorial Hospital (1944); Driscoll Hospital; Thomas-Spann; Hilltop Tuberculosis Hospital (1953); Crippled Children's Hospital (1938); Corpus Christi Osteopathic Hospital; and the Osteopathic Hospital, which was a training facility.

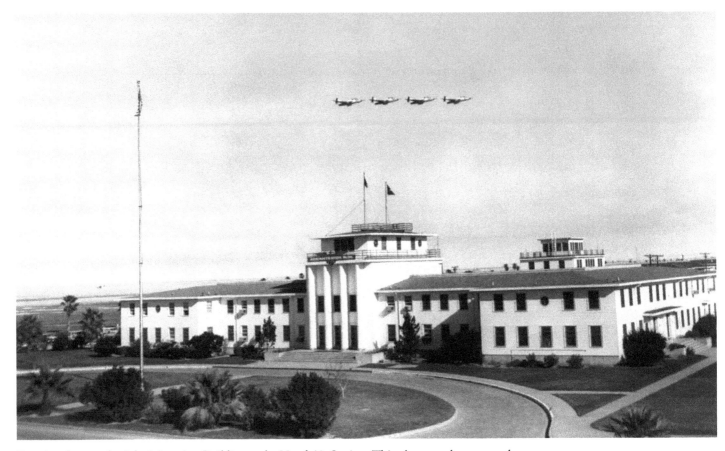

Four jets fly over the Administration Building at the Naval Air Station. This photograph portrays the well-established and manicured lawn in front of the building in 1957.

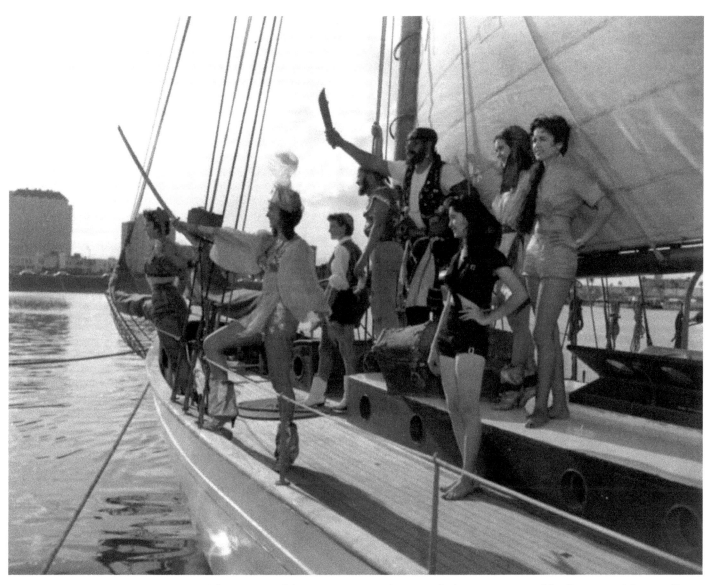

The opening of the Buccaneer Days begins with the reenactment of the discovery of Corpus Christi Bay. These pirates and maids are making their way to the dock in 1957 for the ceremony.

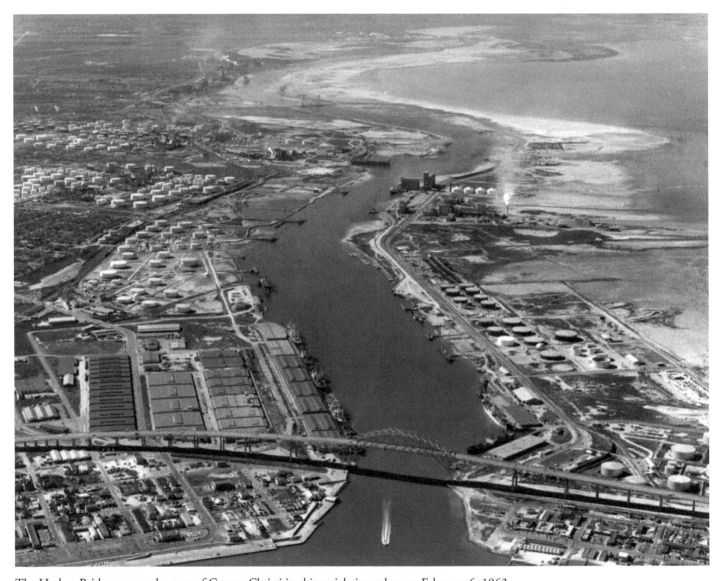

The Harbor Bridge crosses the port of Corpus Christi in this aerial view taken on February 6, 1963.

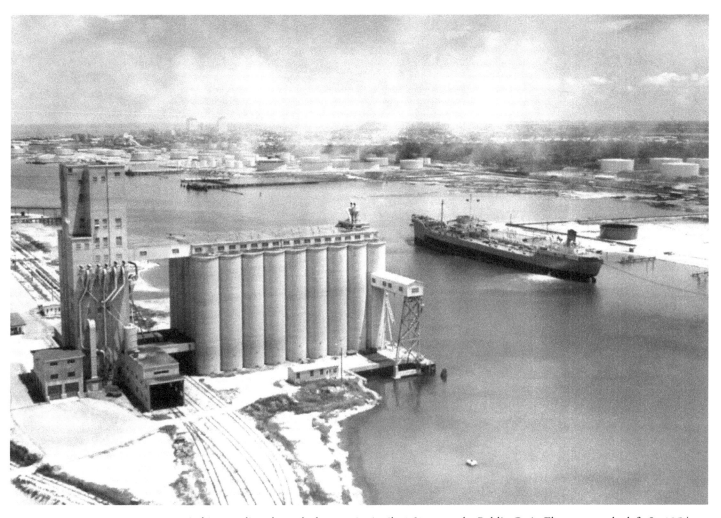

A ship traveling through the port in April 1961 passes the Public Grain Elevators on the left. In 1954, an elevator with a two-million-bushel capacity was opened for storage in this area. In 1959, additional steel tanks were added, as seen in this picture, which increased storage capacity to 4,160,000 bushels. Additional grain elevators would be built several years later and further increase storage capacity by 1.5 million.

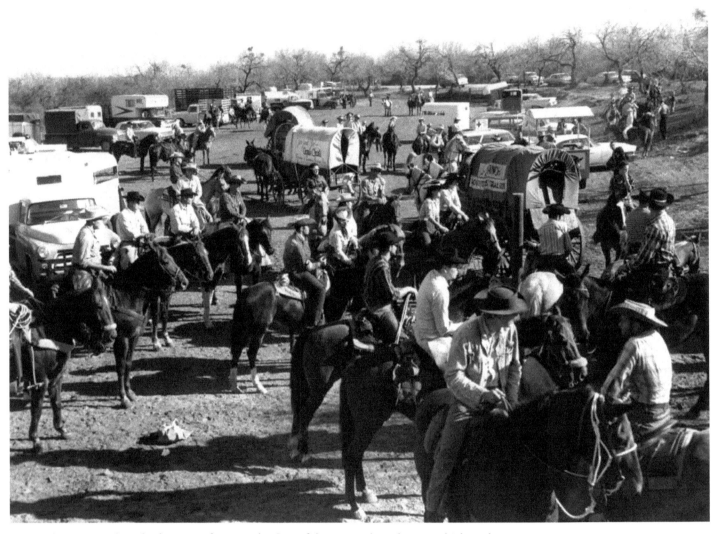

Men and women on horseback gear up for a parade. One of the wagons has a banner which reads
"Sun, Sand & Surf—Corpus Christi Chamber of Commerce—Buccaneer Days."

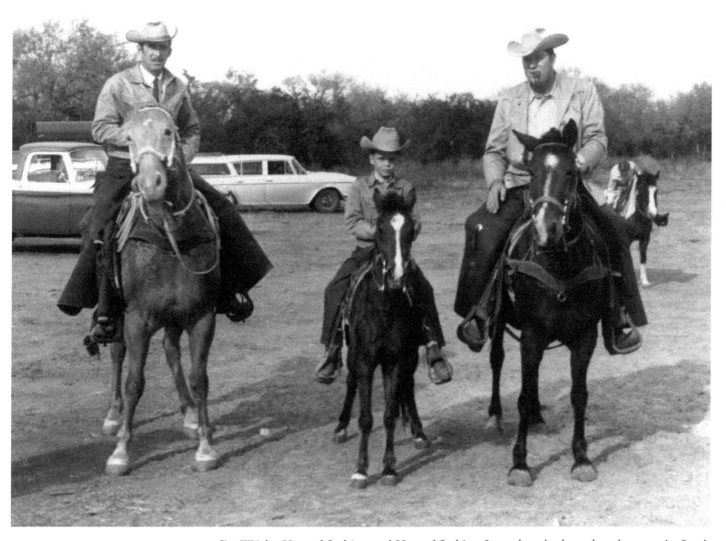

Jim Wright, Howard Stulting, and Howard Stulting, Jr., on horseback, ready to leave on the South Texas Trail Ride. This trail ride began at the J & D Dude Ranch in Corpus Christi on its way to the 1964 Livestock Show and Rodeo in San Antonio.

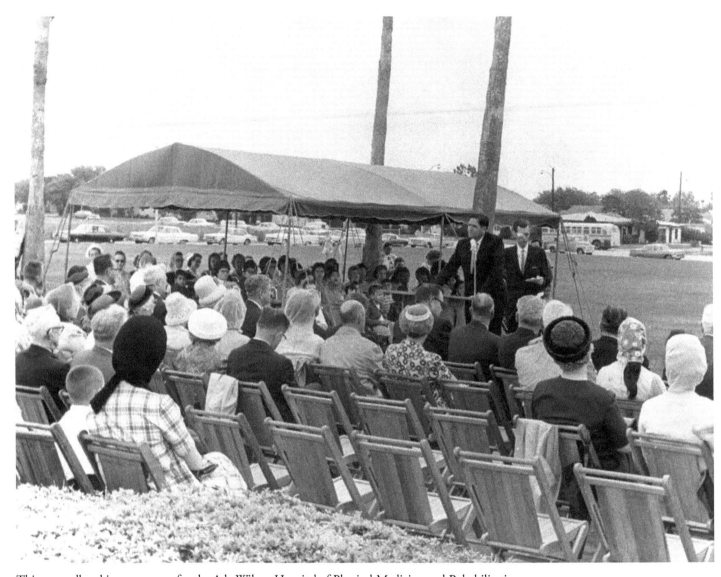

This groundbreaking ceremony for the Ada Wilson Hospital of Physical Medicine and Rehabilitation was held on April 22, 1964, on the driveway of the Driscoll Foundation Children's Hospital. This facility located south of the Driscoll Hospital would be associated with the South Texas Children's Medical Center Foundation. The two speakers are Senator Bruce Reagan, who was master of ceremonies, and Dr. James L. Barnard, mayor.

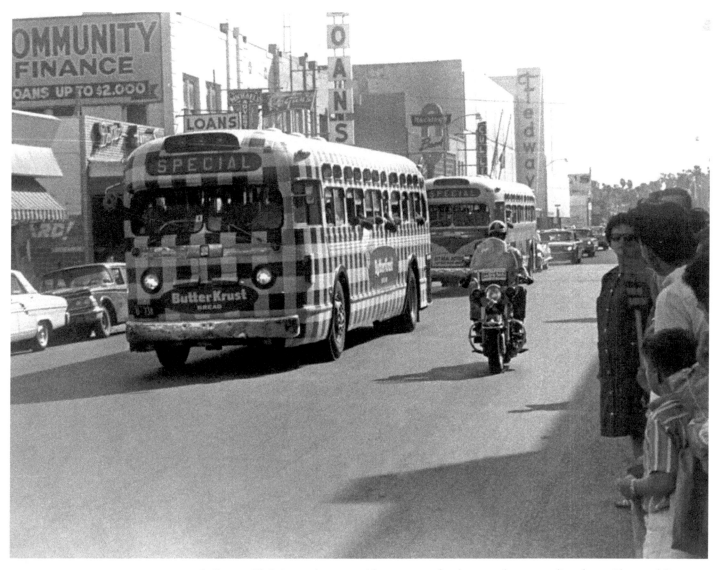

A Corpus Christi patrolman provides an escort for these two buses traveling down Chaparral Street on October 24, 1964.

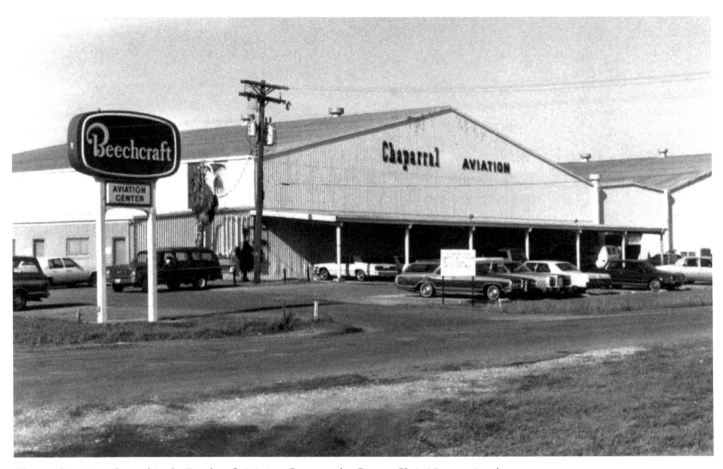

Chaparral Aviation, located in the Beechcraft Aviation Center at the Corpus Christi International Airport, provided a maintenance facility and stored aircraft.

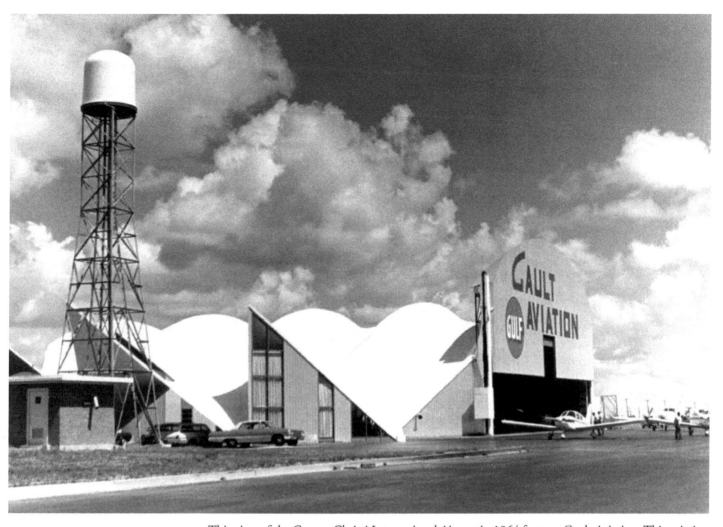

This view of the Corpus Christi International Airport in 1964 features Gault Aviation. This aviation business was operated by Roger and Elaine Gault for 33 years. Both were pilots and served in the Civilian Pilot Training Program. The unique building, designed by architect Joe L. Williams as a hyperbolic paraboloid, housed their business for 15 years.

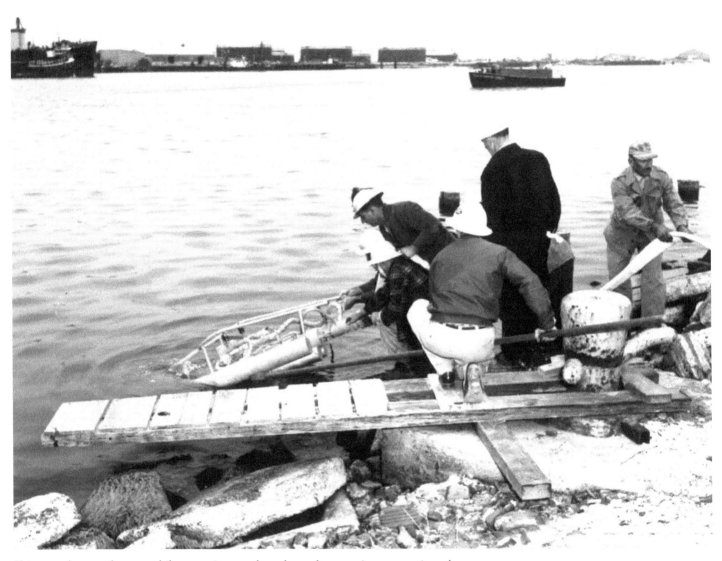

Ships travel across the port while an engineer and employees lower an instrument into the water.

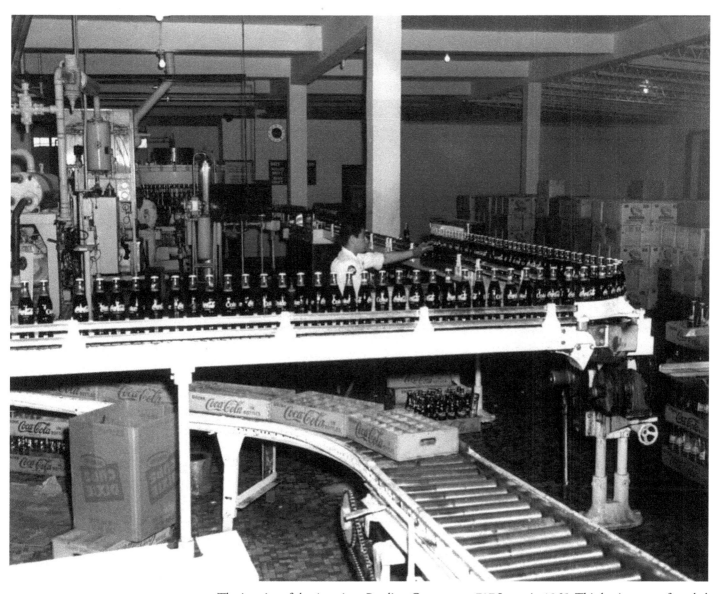

The interior of the American Bottling Company at 717 Lester in 1965. This business was founded by S. W. Dunnam, Sr., who arrived in Corpus Christi in 1904. Originally opened on Water Street, it moved to 1001 Leopard in 1907, and a year later received the Coca-Cola franchise. The soda was bottled by hand until 1921, when semiautomatic equipment was installed. In 1939, the city's first vending machines stocked this popular soft drink.

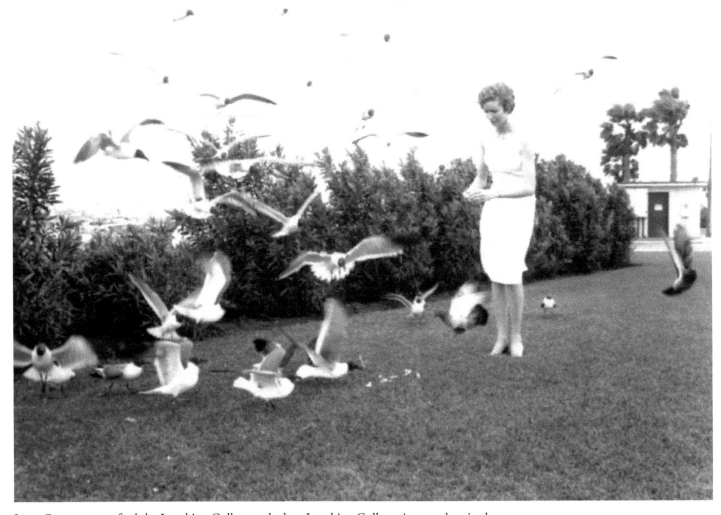

Janet Grant stops to feed the Laughing Gulls near the bay. Laughing Gulls, quite prevalent in the area, entice tourists and residents to throw food in the air. Many people, especially children, like to hear their shrieks and watch them dive to catch a morsel of food sailing through the air.

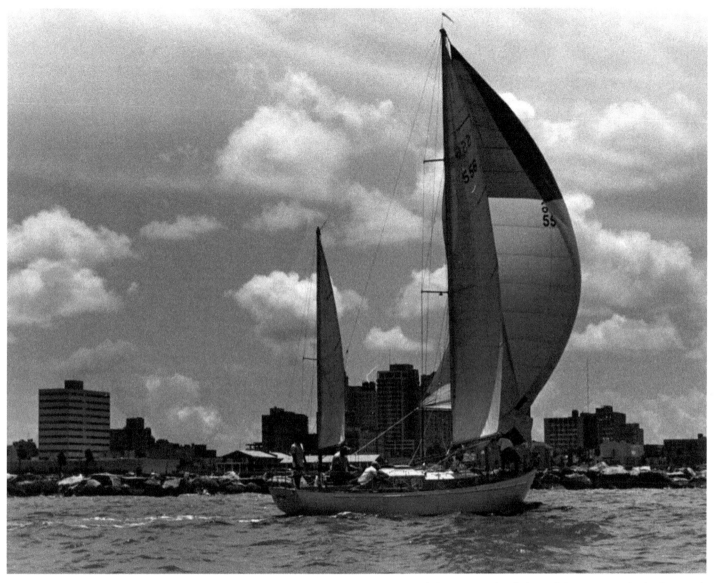

A yacht sails across the bay just beyond the jetties. The skyline of the city is in the background.

The Jaycees of Corpus Christi sponsored Barbara Jones for a beauty contest along the bay.

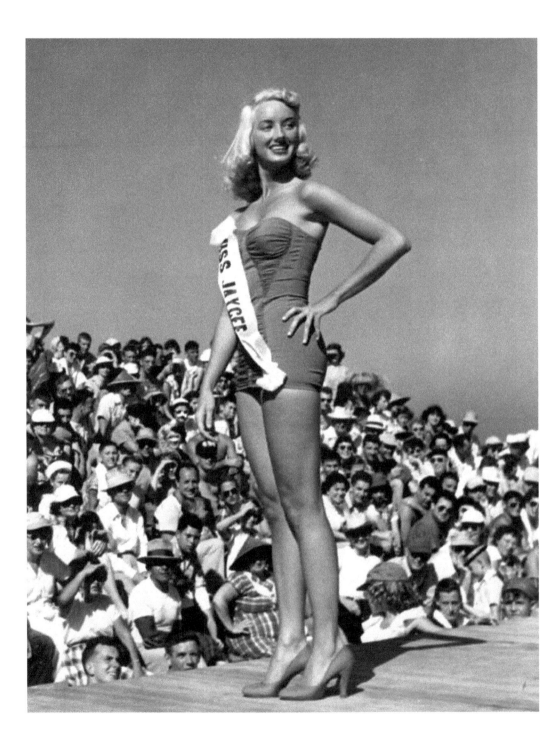

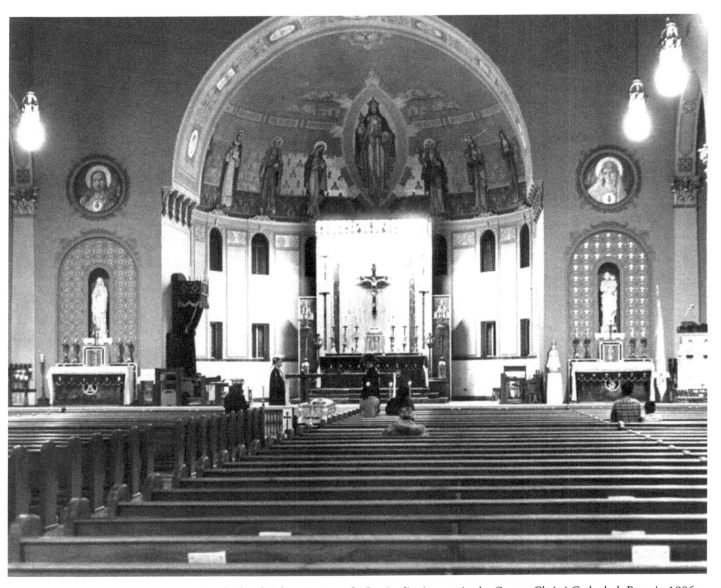

The body of Bishop Mariano S. Garriga lies in state in the Corpus Christi Cathedral. Born in 1886 at Port Isabel, he had been a priest for more than 54 years and the first native Texan to be made bishop. He initiated a seminary in San Antonio and served as chaplain of the Texas Infantry in the Pershing expedition into Mexico and with the 144th Infantry in World War I. He was made Bishop in 1936 and served South Texas for many years.

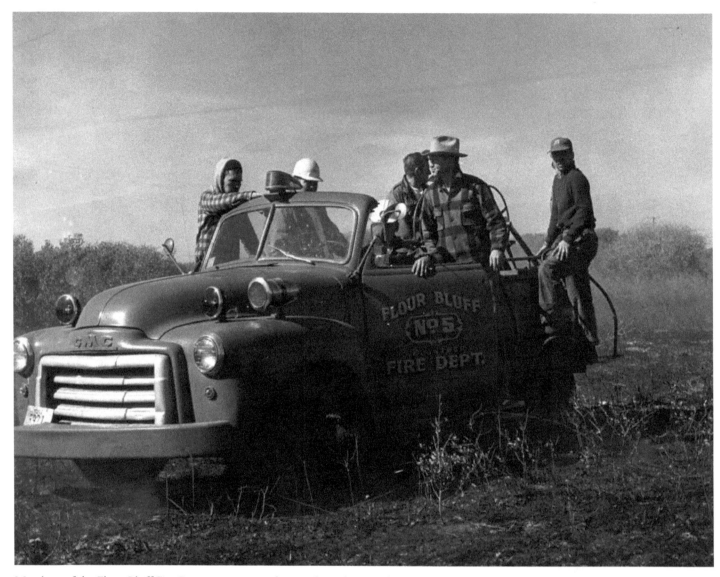

Members of the Flour Bluff Fire Department scout the area from their truck.

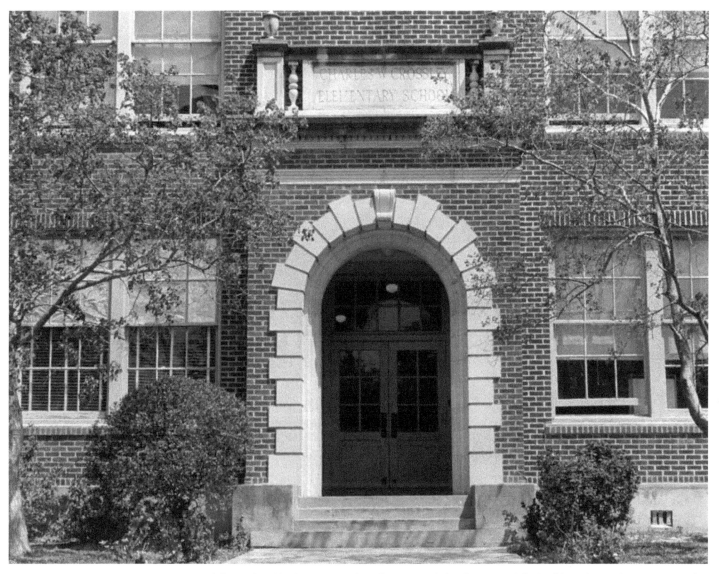

This is the Charles W. Crossley Elementary School in 1965. The building, located at 2512 Koepke, was built in 1926 and has gone through several expansions and renovations. It was named for C. W. Crossley, who served for two years as a principal in Corpus Christi. In 1892, he was promoted to school superintendent and sought to improve the school system until his retirement in 1900.

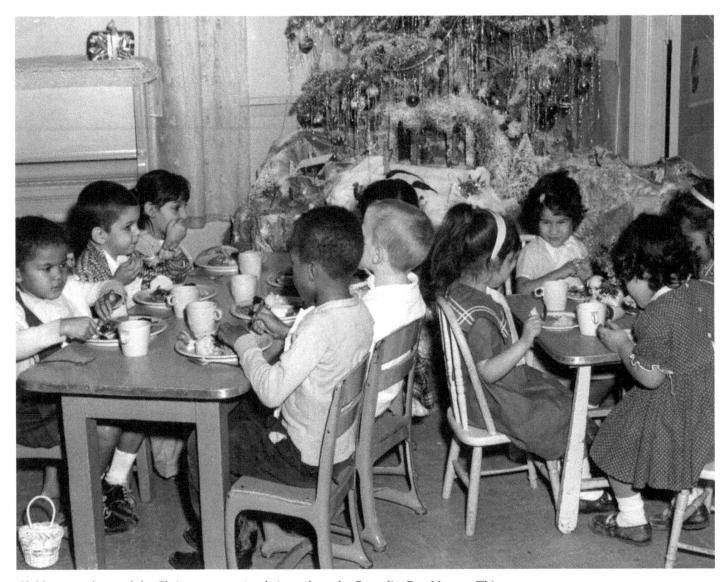

Children seated around the Christmas tree enjoy their snacks at the Carmelite Day Nursery. This nursery was opened in 1925 by four Carmelite Sisters. Since Corpus Christi did not have a nursery to care for children of working women, the sisters provided a necessary service. Their first building, a simple four-story frame house on Last Street (Buffalo and Alameda) expanded through the years to handle the growing population.

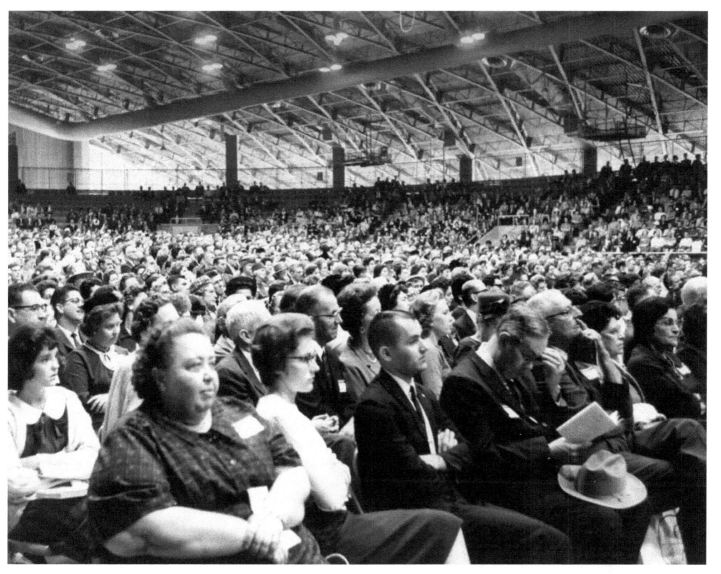

A crowd fills the inside of the Memorial Coliseum. This building designed by Richard Colley received its name in 1954 when the American Gold Star Mothers, a club for women who have lost children in war, placed a plaque on it to honor those lost in World War II. The building served as the city's social and political center for many years.

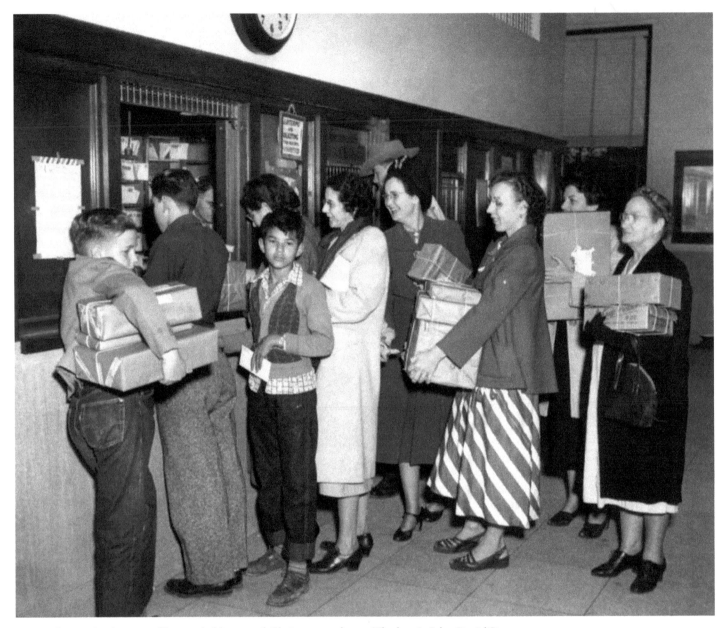

Patrons line up in the post office, probably to mail Christmas packages. The boy is John David Parr. Mrs. Ethel Bryant and Mrs. Walton Tally are among those standing in line.

Notes on the Photographs

These notes, listed by page number, attempt to include all aspects known of the photographs. Each of the photographs is identified by the page number, a title or description, photographer and collection, archive, and call or box number when applicable. Although every attempt was made to collect all data, in some cases complete data may have been unavailable due to the age and condition of some of the photographs and records.

71 **SHOE STORE**
Corpus Christi Public
Libraries
Photo by Doc McGregor
Collection F1 Box 9 Folder
9.58 Item 5

72 **ROTC IN PARADE**
Corpus Christi Public
Libraries, Collection F1 Box
25 Folder 25.01 Item 1

74 **DRIVE-IN EATERY**
Library of Congress
LC-USF34-038273-D

75 **DRAUGHONS PRACTICAL
BUSINESS COLLEGE**
Corpus Christi Public
Libraries, Collection F1 Box
5 Folder 5.34 Item 2

76 **HIGH SCHOOL BUCCANEER
FOOTBALL**
Corpus Christi Public
Libraries, Collection F1 Box
24 Folder 24.07 Item 7

77 **CORPUS CHRISTI NAVAL
HOSPITAL**
Corpus Christi Public
Libraries, Collection F1 Box
4 Folder 4.25 Item 1

78 **SOUTHERN PAINT SUPPLY**
Corpus Christi Public
Libraries, Collection F1 Box
9 Folder 9.45 Item 1

79 **NAVY AD**
Special Collections &
Archives, Texas A&M
University-Corpus Christi,
Bell Library, Smiley
Collection 9, 2.12

80 **DRUGSTORE SODA FOUNTAIN**
Special Collections &
Archives, Texas A&M
University-Corpus Christi,
Bell Library, Smiley
Collection 9, 26.6

81 **A MUSEMENT PARK**
Special Collections &
Archives, Texas A&M
University-Corpus Christi,
Bell Library, Smiley
Collection 9, 29.6

82 **PILOT**
Special Collections &
Archives, Texas A&M
University-Corpus Christi,
Bell Library, Smiley
Collection 9, 26.6

83 **U .S. NAVY FLEET OF
PLANES**
Special Collections &
Archives, Texas A&M
University-Corpus Christi,
Bell Library, Smiley
Collection 9, 29.20

84 **WAVES**
Special Collections &
Archives, Texas A&M
University-Corpus Christi,
Bell Library, Smiley
Collection 9, 29.3
(McGregor
Studio)

85 **BUILDING A PLANE**
Special Collections &
Archives, Texas A&M
University-Corpus
Christi, Bell Library,
Smiley Collection 9, 29.23
(McGregor Studio)

86 **RELAXING AT A CLUB**
Special Collections &
Archives, Texas A&M
University-Corpus Christi,
Bell Library, Smiley
Collection 9, 26.6
(McGregor
Studio)

87 **THE RED CROSS WAR
EFFORT**
Special Collections &
Archives, Texas A&M
University-Corpus Christi,
Bell Library, Smiley
Collection 9, 26.6
(McGregor
Studio)

88 **RADIO TELEPHONE
INSTRUCTION**
Library of Congress
LC-USW3-034012

89 **NAVAL AIR BASE
ENTERTAINMENTS**
Special Collections &
Archives, Texas A&M
University-Corpus Christi,
Bell Library, Smiley
Collection 9, 26.6
(McGregor
Studio)

90 **NAVY BAND**
Special Collections &
Archives, Texas A&M
University-Corpus Christi,
Bell Library, Smiley
Collection 9, 26.6
(McGregor
Studio)

91 **CORPUS CHRISTI FIRE
DEPARTMENT DRILL**
Corpus Christi Public
Libraries, Collection F1 Box
4 Folder 4.21 Item 11

92 **UPPER BROADWAY**
Corpus Christi Public
Libraries, Collection F1 Box
1 Folder 1.26 Item 10

93 **ADMIRAL C. W. NIMITZ**
Corpus Christi Public
Libraries, Collection F1 Box
27 Folder 27.10 Item 1

94 **CHURCH OF THE GOOD
SHEPHERD**
Corpus Christi Public
Libraries, Collection F1 Box
4 Folder 4.04 Item 5

95 **CAMP FIRE GIRLS**
Special Collections &
Archives, Texas A&M
University-Corpus Christi,
Bell Library, Smiley
Collection 9, 26.6
(McGregor
Studio)

96 **THE BLUE ANGELS**
Corpus Christi Public
Libraries, Collection F1 Box
1 Folder 1.11 Item 6

97 **HECTOR P. GARCIA**
Special Collections &
Archives, Texas A&M
University-Corpus Christi,
Bell Library
Garcia Collection 5

98 **NORTH GATE SENTRY HOUSE**
Corpus Christi Public
Libraries, Collection F1 Box
27 Folder 27.11 Item 1

100 **LA RETAMA PUBLIC
LIBRARY BOOKMOBILE**
Corpus Christi Public
Libraries, Collection F1 Box
4 Folder 4.40 Item 13

101 **W. W. JONES HOUSE**
Corpus Christi Public
Libraries, Collection F1 Box
4 Folder 4.40 Item 4

102 **JOE J. ALSUP**
Corpus Christi Public
Libraries, Collection F1 Box
6 Folder 6.47 Item 6

103 **CORPUS CHRISTI TRUST
COMPANY**
Corpus Christi Public
Libraries, Collection F1 Box
6 Folder 6.30 Item 2

104 **CORPUS CHRISTI BANK AND
TRUST COMPANY**
Corpus Christi Public
Libraries, Collection F1 Box
6 Folder 6.30 Item 5

105 **FIRST BAPTIST CHURCH**
Corpus Christi Public
Libraries, Collection F1 Box
4 Folder 4.07 Item 3

106 **THE INGER**
Corpus Christi Public
Libraries, Collection F1 Box
12 Folder 12.14 Item 19

107 **DEL MAR COLLEGE AFFAIR**
Corpus Christi Public
Libraries, Collection F1 Box
5 Folder 5.32 Item 21